Sarah Charlesworth: Doubleworld

Edited by Margot Norton and Massimiliano Gioni

NEW MUSEUM

Contents

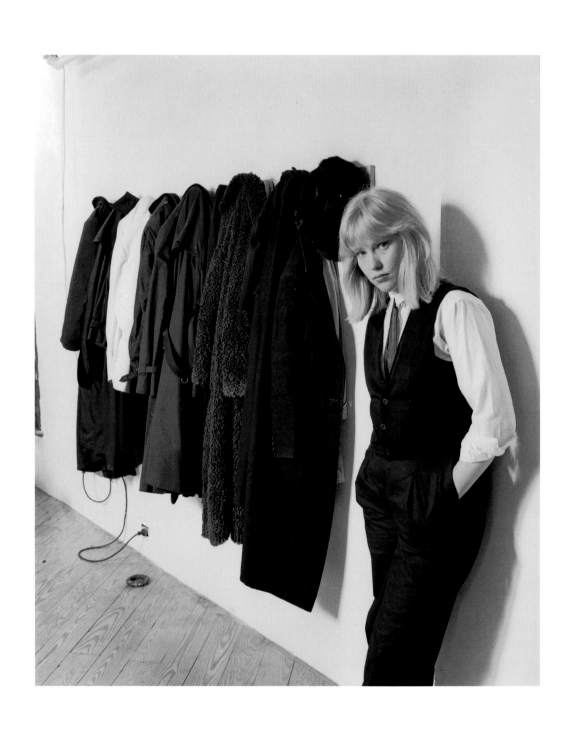

Sarah Charlesworth in her studio, New York, 1984. Photo: Peter Sumner Walton Bellamy

Introduction

Thirty-eight years ago, when I was still a student, I made my way to a panel discussion at the School of Visual Arts headlined by several successful, well-known male artists who drew an overflow crowd. There was one woman on the panel—Sarah Charlesworth—who looked just a bit older than me, perhaps in her early thirties. At the time, I didn't know her or her work, but I was stunned. She was a luminous presence on that stage, commanding in her confidence and articulation of ideas, and she took on the heavy hitters with ease (actually shocking us by mostly reducing them to silence). Formidably intelligent, tough, fearless, independent, and unapologetically feminine, she presented a new standard for many of us. Her radiance, brilliance, seriousness, and rigor gave us courage to embrace femininity, intellectual life, and spiritual life. Sarah was tough, but she was equally kind and generous. These are qualities that made her such an influential teacher and mentor to so many. These are the qualities that made her an exceptional artist.

Fast forward to 1984, when I was a young curator at the Whitney Museum of American Art and working on my first biennial. I saw Charlesworth's exhibition at the Clocktower in New York—which featured her series "Tabula Rasa" (1981), "In-Photography" (1981–82), and "Objects of Desire" (1983–88)—and was riveted. Charlesworth's practice bridged the incisive rigor of 1970s Conceptual art and the illuminating image-play of what would become known as the "Pictures Generation." As has often been written, she was part of a group of artists working in New York in the 1980s—which included Jack Goldstein, Sherrie Levine, Richard Prince, Cindy Sherman, and Laurie Simmons, among others—that plumbed the visual language of mass media and illuminated the imprint of ubiquitous images on our everyday lives. These artists were more likely to make rather than take photographs, using preexisting images or templates for their work. In a 1990 interview, Charlesworth noted that:

> I don't think of myself as a photographer. I've engaged questions regarding photography's role in culture…but it is an engagement with a problem rather than a medium. The creative part of the work is just as much like painting or design as it is like photography. I'm not using a camera and it's not based on recording a given world but on creating or structuring a given world.[1]

The role of women in this movement is still under recognized. A strong group of artists—including Charlesworth, Levine, Sherman, and Simmons, as well as Jenny Holzer, Barbara Kruger, and Louise Lawler, among others—shared an interest in collapsing collective meaning to create a world of their own choosing. And the key issue here was representation: who produces images and how are they distributed, controlled, selected, and consumed? Together these

1. Betsy Sussler, "Sarah Charlesworth," *BOMB* 30 (Winter 1990), 32–33.

women had a profound impact on the art of our time by moving a medium previously considered secondary, to the center of artistic debate and by using the poor stepchild of painting and sculpture to question the tenets of modernism and to bring this era to an end.

I selected several works for the Whitney from the "Objects of Desire" series, and Sarah arrived at the biennial opening very pregnant with her son, Nick. Not only was she making spectacular and important work that was defining a moment and redefining both art and photography—she was also starting a family! That was pioneering in 1985. At least, I didn't know many other women who were doing both. I admired how she managed it all: mother, wife, artist, teacher, friend. She showed that women could work against expectations and constraints and achieve a work-life balance. We soon became friends and part of a group of women who were changing things in the art world in the '80s. Sarah was a kind of big sister to many of us. She and I became even closer when she was represented by Meyer Vaisman, a director of the East Village gallery International With Monument, who would soon become my husband.

But juggling the demands of mother, wife, artist, and provider was not without its challenges, as I soon came to learn from Sarah. The economic downturn of the early '90s took its toll on everyone. After her initial early success, she struggled to find the right commercial representation, and a large traveling survey organized by Louis Grachos in 1997 for SITE Santa Fe (for which Grachos invited me to write a catalogue essay) never made it to New York, despite many efforts. We worked together on several group shows that I organized during this time—"Image World: Art and Media Culture" with Marvin Heiferman (1989), "Photoplay: Works from the Chase Manhattan Collection" with Manuel E. Gonzalez (1993–94), and "The American Century: Art & Culture, 1950–2000" (1999)—but major solo shows remained elusive. Throughout this period she was grounded by her family, her students, and her friends, and she kept on working and teaching though her public presence was far less visible.

In the years just before her death in 2013, things were turning around again. Her children were grown and flourishing. She had a new love in her life and was enjoying working and gardening in a new house in Connecticut that brought her back to her New England roots. Most importantly though, her early works were being recognized as historical icons, and several significant pieces entered major museum collections, including the Metropolitan Museum of Art, New York; the Museum of Modern Art, New York; and the Art Institute of Chicago. I'm glad she lived to see this well-deserved recognition and resurgent interest.

And so it was thrilling for me, on a recent trip to Chicago, to see our curators respond so strongly to a group of works—the "Stills" series (1980)—on view at the Art Institute, and then have them subsequently propose this exhibition. It is truly an honor to be able to present Charlesworth's work at the New Museum, where she exhibited many times, especially with a new generation of curators that is rediscovering her considerable talents and bringing fresh scholarship and insights to her work.

"Sarah Charlesworth: Doubleworld" is the first major survey in New York of the artist's work, encompassing a forty-year career that played a crucial role in establishing photography's centrality to contemporary art. The exhibition features her aforementioned series "Stills," the poignant group of fourteen

large-scale works rephotographed from press images that hauntingly depict people falling or jumping from tall buildings. This installation of "Stills" marks the first time that the complete series has been displayed in New York and is presented as part of this survey of Charlesworth's most prominent works: her groundbreaking first mature series "Modern History" (1977–79); the alluring and exacting "Objects of Desire"; "Doubleworld" (1995), which probes the fetishism of vision in premodern art and marks Charlesworth's transition to a more active role behind the camera; and her radiant latest and last series, "Available Light" (2012). Taken together, the exhibition is a thoughtful presentation of a rich and diverse output.

Admired for asking pivotal questions about the role of images in our culture, Sarah Charlesworth produced an innovative, influential body of work that dissects pictorial codes and deconstructs the conventions of photography while breathing new life into photography and art. She was cerebral and sensual, secular and spiritual, and her work crossed so many boundaries, embraced hybrid forms, and refused to adhere to strict orthodoxies. She was interested in photography's importance in mediating our view of the world and our own subjective constructions, but she was equally interested in light, perception, magic, and alchemy—all elements at the core of the medium.

Lisa Phillips
Toby Devan Lewis Director

Acknowledgements

"Sarah Charlesworth: Doubleworld" brings together a selection of more than fifty remarkable works from over the course of Charlesworth's career. I would like to thank Massimiliano Gioni, Artistic Director, for spearheading this project and Margot Norton, Associate Curator, for working closely with the Estate of Sarah Charlesworth to organize this exhibition and accompanying catalogue. Joshua Edwards, Director of Exhibitions Management, and his team members—Melisa Lujan, Registrar; Walsh Hansen, Chief Preparator; Kelsey Womack, Exhibitions Associate; and Jillian Clark, Production Assistant—worked tirelessly on the show's complicated planning and installation. I would also like to acknowledge Karen Wong, Deputy Director; Regan Grusy, Associate Director and Director of Institutional Advancement; and Johanna Burton, Keith Haring Director and Curator of Education and Public Engagement. They and their respective teams provided enthusiastic support for the exhibition throughout its development. Curatorial Interns Virginia Colombo, Daniel Gallagher Merritt, Amanda Ryan, and Jieun Seo also contributed significantly to the project at various stages of its evolution.

This exhibition catalogue illuminates Charlesworth's influential legacy and trenchant approach to the photographic medium. Joseph Logan and Rachel Hudson at Joseph Logan Design have produced a thoughtful design that captures the beauty and complexity of Charlesworth's oeuvre. Johanna Burton, Hal Foster, Kate Linker, Margot Norton, Cindy Sherman, Laurie Simmons, and Sara VanDerBeek each offer a unique perspective on aspects of Charlesworth's art practice, and I am grateful to them for their contributions. I also extend my thanks to the Estate of Sarah Charlesworth; David Clarkson; Barbara Kruger; Knight Landesman, Publisher, *Artforum*; and Betsy Sussler, Editor in Chief, *BOMB*; for allowing important texts to be reprinted in our publication. Frances Malcolm, Editor and Publications Coordinator, and Olivia Casa, Assistant Editor, provided thoughtful editing, and their hard work and insights are evident throughout. Marina Chao, Curatorial Assistant, the International Center of Photography, New York; Matthew C. Lange, Charlesworth's studio assistant; artist Sara Greenberger Rafferty; and Tony Shafrazi also provided crucial advice and support in compiling research and materials for this publication.

"Stills" is presented in association with the Art Institute of Chicago, and I am grateful to Douglas Druick, President and Eloise W. Martin Director; Matthew S. Witkovsky, Richard and Ellen Sandor Chair and Curator, Department of Photography; and Jennifer Draffen, Executive Director for Exhibitions and Registration; at the Art Institute of Chicago for making the presentation of this remarkable series possible. The following individuals and institutions also allowed us to present wonderful pieces that are central to the exhibition: Dr. Dana Beth Ardi; Christopher and Felicitas Brant;

Melva Bucksbaum and Raymond Learsy; Richard Edwards, Aspen; the Estate of Sarah Charlesworth and Maccarone Gallery, New York; Joy L. Glass and Richard Milazzo, New York; Barbara and Irvin Goldman; Jay Gorney and Tom Heman; Judith Hudson, New York; Howard Bates Johnson; Nicole Klagsbrun; Ingo Kretzschmar; Montclair Art Museum; the Museum of Modern Art, New York; B.Z. and Michael Schwartz, New York; Leigh and Reggie Smith; Jennifer and David Stockman; the Whitney Museum of American Art, New York; and several private collections.

A number of individuals provided assistance in securing key loans for the exhibition, and I would like to thank them here: Carol Deer; Ryan Frank; Gail Stavitsky, Chief Curator, Montclair Art Museum; Quentin Bajac, Chief Curator of Photography, and Roxana Marcoci, Senior Curator, Department of Photography, the Museum of Modern Art, New York; and Carter E. Foster, Steven and Ann Ames Curator of Drawing, David Kiehl, Nancy and Fred Poses Curator, Dana Miller, Curator, Permanent Collection, and Adam Weinberg, Alice Pratt Brown Director, the Whitney Museum of American Art, New York.

We are exceptionally grateful for the generous support of the Robert Mapplethorpe Foundation and the Friends of Sarah Charlesworth at the New Museum—Ara Arslanian; Melva Bucksbaum and Raymond Learsy; Joseph Kosuth; Margo Leavin; Toby Devan Lewis; Maccarone Gallery, New York; Peter Marino; Tony Shafrazi; S.L. Simpson; and Neda Young—for recognizing the significance of this exhibition. This catalogue is made possible by the J. McSweeney and G. Mills Publications Fund at the New Museum.

Finally, this exhibition would not have been possible without the generous support and assistance of the Estate of Sarah Charlesworth—especially Charlesworth's children, Nick and Lucy Poe; Jay Gorney, Advisor to the Estate of Sarah Charlesworth; and Michele Maccarone of Maccarone Gallery, New York; all of whom worked closely with the New Museum to realize our shared vision for the exhibition. I would like to thank Ellen Langan and Mara Mckevitt, also at Maccarone Gallery, for helping with particular aspects of the presentation. Matthew C. Lange was an especially invaluable resource, and this exhibition is indebted to his wealth of knowledge, hard work, and insight.

Lisa Phillips
Toby Devan Lewis Director

Tabula Rasa, 1981. White-on-white silkscreen print, 66½ x 92½ in (168.9 x 235 cm)

Seven Types of Ambiguity

Hal Foster

Ambiguity is everything in postmodernist art, and so it is with the work of Sarah Charlesworth: she liked to turn the received ideas of visual culture into productive paradoxes, questioning other clichés in the process, such as the notion that critical art is always didactic or obviously political. Here are seven of the paradoxes that Charlesworth put into play.

1. Photography as a Problem

"I don't think of myself as a photographer," Charlesworth once remarked; "it is an engagement with a problem rather than a medium."[1] With this statement she spoke for an entire group of young artists that we now know as the "Pictures Generation" (her female colleagues include Barbara Kruger, Louise Lawler, Sherrie Levine, Cindy Sherman, Laurie Simmons...). Variously initiated into strategies of Conceptual art, performance, and institutional critique of the 1960s and 1970s, these artists were also differently marked by new developments in the 1980s, such as a qualitative expansion of mass media, which changed the terms of image production, distribution, and reception, and an increased sophistication in feminist theory, which foregrounded the question of sexual difference in visual representation. Most of these artists also struggled with the ambiguous model of Andy Warhol, who appeared to collude with the very image-world that he exposed. Certainly Charlesworth contended with him, and her critical elaboration of Pop art, complicated with Conceptualism and cut by feminism, is a key instance of postmodernist practice.

Charlesworth advanced her problematizing of photography on several fronts at once. On one side, she was opposed to an art photography that assumed the values of the unique image associated with painting (such photography had only begun to attract a strong market in the early 1980s); on the other side, she was suspicious of all media reproductions that worked to produce effects of consensus in the news and persuasion in advertising. Made of purloined photographs, her art was positioned, too, against Neo-Expressionist painting of the time with its forced reclamation of the male artist as originary genius.[2] Like her colleagues, Charlesworth tended to treat the photograph not only as a serial image, a multiple without a unique print, but also as a simulacral image, a representation without a guaranteed referent in the world. In this way, she regarded the photograph less as a physical trace or an indexical imprint of reality than as a coded construction that produces real effects as well as artificial affects, and she dedicated her work to an exploration of this rhetoric of the image.[3] Charlesworth was an attentive witness to the lives of photographs, and she invited us to be more self-aware about our status as image witnesses as well.

Take her early series "Tabula Rasa" (1981), four near-white silkscreens based on one candidate for the first photograph, a faint image of a dinner table

1. Betsy Sussler, "Sarah Charlesworth," *BOMB* 30, Winter 1990, 32–33.
2. In *Samurai* (1981), Charlesworth reworked a photograph of a samurai warrior wielding his sword such that he seems to slash this very image (which is also his very image)—a witty parody of the macho aggression of the Neo-Expressionist gesture.
3. Roland Barthes was a crucial guide here, as were Jean Baudrillard, Michel Foucault, and Gilles Deleuze for their accounts of the simulacrum, a notion that Baudrillard used to understand recent transformations in the commodity and that Foucault and Deleuze used to question conventional conceptions of representation. Today these concerns might seem obvious (e.g., who among us believes in the transparency of the photograph?) or outdated (e.g., our problem might be less the concentration of the image in spectacle than its circulation in a system of networks). But Charlesworth asked questions—about the manufacture of consent and the vicissitudes of fetishism, among others—that remain as pertinent as ever.

produced by Joseph Nicéphore Niépce in the 1820s. The original, a glass plate long lost, exists only as a faded paper version, the one that Charlesworth reworked here with slight variations in each case; with this deft gesture she complicated any attempt to uphold a hierarchy of original and copy. Today this sounds like Walter Benjamin 101—the reproducibility of the photograph challenges the aura of the unique artwork—but it was not so obvious in 1981.[4] Nor is this quite what happens, or all that happens, in "Tabula Rasa," for even as Charlesworth questioned the status of the original, she did not simply dispatch its aura. On the contrary, she showed how that aura is conjured, and how copies support originals as much as subvert them (categorically, of course, the concept of "original" depends on that of "copy").

2. To Subtract is to Add

A familiar definition of collage is the one that animated Surrealist practice: a combination of two or more heterogeneous things on a plane that does not suit them. But what if collage were rethought as a process of subtraction, not addition—of cutting away, not gluing together? This is what Charlesworth proposed in her first series, "Modern History" (1977–79). For one section of the work she photocopied the front pages of the *International Herald Tribune* for the month of September 1977, whiting out everything except the masthead and the photographs. At first glance, this deletion only produces arbitrary juxtapositions, but the patriarchal structuring of the news becomes apparent once we notice the recurrence of male heads of states. With the simple device of the newspaper as assisted readymade (deployed to different ends by Warhol and Dan Graham), Charlesworth underscored the first priority of official media: the maintenance of political authority.

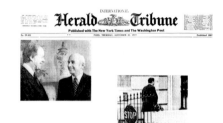

"Modern History" suppresses informational content in order to reveal ideological structure. Charlesworth performed a different sort of negative montage in another series, "Stills" (1980), in which news photos of individuals in free fall are enlarged even as the world around them is elided; in one work, *Unidentified Woman (Vera Atwool, Trinity Towers, Louisville, KY)*, a body hangs in midair against a brick wall. Do these people leap to death or to safety? "Neither the intention nor the outcome of the jump is apparent," Charlesworth stated matter-of-factly, which suggests that the subject here is less the patterning of information than the ambiguity of signification—in particular the paradox that to subtract literal reference (or denotation) is often to expand allusive meaning (or connotation).[5]

Herald Tribune, September 1977 (details), from the "Modern History" series, 1977. Twenty-six black-and-white prints reproduced at the same size as the original newspapers, dimensions variable, approximately 22 x 16 in (55.9 x 40.6 cm) each

Again, do these souls fall or fly? Is the stillness of "Stills" one of imminent death or sudden grace? Strictly speaking, it is impossible to know, but one senses that these works are less about semiotic undecidability than about existential decision: both very great, the taking of a life, and rather minor, the taking (or the selecting) of a photograph. In this respect they call up Warhol again, not only his silkscreens of falling bodies (Charlesworth adapted one of his suicides in her own series), but also his obsession with "death in America"—that is, with mass subjects and anonymous victims (signaled here by all the "Unidentifieds" in the titles). Perhaps more than any peer except Richard Prince, Charlesworth developed this dark side of Warholian Pop. At the same time, "Stills" points to the old association, active in superstition and theory alike, between photography and death: the

4. I refer, obviously, to Walter Benjamin, "The Work of Art in the Age of its Technological Reproducibility" (1936), in Michael Jennings et al., eds., *Selected Writings, Volume 3: 1935-1938* (Cambridge, MA: Harvard University Press, 2002). In *After Art* (Princeton, NJ: Princeton University Press, 2012), David Joselit argues that this great essay is now as constrictive to our thinking about the lives of images as it once was productive.

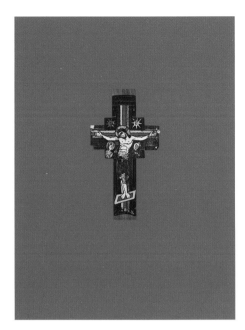

Cross, from the "Objects of Desire" series, 1986. Cibachrome print with lacquered wood frame, 42 x 32 in (106.7 x 81.3 cm)

suspicion that the photograph steals the soul, the notion (shared by Jacques Lacan, Roland Barthes, and many others) that the photograph not only stills its human subjects but also mortifies them.

3. Aura Lost and Regained

Benjamin 101 has it that photographic reproduction tends to strip the artwork of its context, to shatter its tradition, to liquidate its aura. Yet there is another position on this decontextualization, one advanced by André Malraux in his famous account of "the museum without walls," which he first sketched while in dialogue with Benjamin. For Malraux, photographic reproduction does not vacate originality so much as it shapes this value, and though the reproduced artwork loses some of its properties as an object, it gains others, such as "the utmost significance as to style," in the exchange.[6] It is this dialectic between de-auraticization and re-aestheticization that Charlesworth staged in her fundamental series "Objects of Desire" (1983–88). Here the rephotography of solitary artworks on lush grounds of color—an African mask on a black field in *Black Mask* (1983) or a Byzantine crucifixion on a red field in *Cross* (1986)—both evokes the aura of the precious artwork and suggests that its charismatic style is largely a special effect. We see how an emblem, an icon, or a cliché is produced. In this way, Charlesworth played both sides of the Benjamin-Malraux debate, pitting one position against the other, and what drove this dialectic was, again, the operational paradox of her work—that to subtract meaning and value is often to augment them, to reduce effect and affect is often to increase them. To the Lacanian formula "desire is born of lack," she added, "and it is fattened through famishing."

4. The Sex Appeal of the Inorganic

In most of the works in "Objects of Desire," Charlesworth appropriated images from glossy magazines, edited them further, then rephotographed them on saturated color fields. These fragments of posed models and displayed accessories suggest a language of desire, a desire that is highly fetishistic, which Charlesworth underscored with the shiny allure of her Cibachrome prints and lacquered frames. Some of these works present solitary traces of the female body, such as a chic scarf, while others juxtapose two or more images for our reflection, a reflection that is simultaneously aesthetic and critical. *Figures* (1983–84) sets a female torso wrapped in a dinner dress on a red ground next to a female body bound in fabric on a black ground. Here, as Abigail Solomon-Godeau wrote, "the (desirable) female body is bound not only by the gown, but by the cultural conventions of desirability, and the delimiting and defining convention of representation itself."[7] We are left to contemplate the vicissitudes of "figures" in the sense both of enforced ideals of beauty and of entrenched forms of figuration.

 Fetishism is a confusion about how things are produced, as in commodity fetishism, or in what things should be desired, as in sexual fetishism; it also involves a displacement in value from a person to an object, as when a pointy shoe or indeed a chic scarf is preferred to a human being. Benjamin once defined fetishism as "the sex appeal of the inorganic," and it is a common way for us to forfeit a part of our humanity in our everyday interactions

5. Interest in semiotic ambiguity was central to postmodernist art—Douglas Crimp referred it to the Symbolist poetics of Stéphane Mallarmé, Craig Owens to the theory of allegory in Paul de Man, and others to "the third meaning" that Roland Barthes detected in the film still. See Douglas Crimp, "Pictures," *October* 8 (Spring 1979); Craig Owens, "The Allegorical Impulse: Toward a Theory of Postmodernism," *October* 12 and 13 (Spring and Summer 1980); and Roland Barthes, "The Third Meaning: Research Notes on Some Eisenstein Stills," in *Image-Music-Text*, ed. and trans. Stephen Heath (New York: Hill & Wang, 1977). This ambiguity has made "Stills" open to resignification over time; for example, the works were revised anachronically, reanimated uncannily, by the victims who leapt from the World Trade Towers on 9/11. See Peter Eleey, *September 11* (New York: MoMA P.S.1, 2011), and Matthew S. Witkovsky, ed., *Sarah Charlesworth: Stills* (Chicago and New Haven: Art Institute of Chicago and Yale University Press, 2014).
6. André Malraux, *The Voices of Silence*, trans. Stuart Gilbert (Princeton, NJ: Princeton University Press, 1978), 112. Also see my "Archives of Modern Art," in *Design and Crime (and Other Diatribes)* (New York and London: Verso, 2002).
7. Abigail Solomon-Godeau, *In Plato's Cave* (New York: Marlborough Gallery, 1983).

with others.[8] In Freud, fetishism crystallizes at moments of charged sight—moments of seeing and not seeing at once—and it is active in the visual realm not only of consumption but also of art. All of this is highlighted in the "Objects of Desire" works, some of which reflect on the conflation of the commodity fetish with the sexual fetish as products and bodies exchange properties as well as parts. This conflation of fetishisms was still novel at the time of Pop art (the key figure here is Richard Hamilton), a function of a consumerist economy in which the production of commodities became evermore obscure and our libidinal investment in them evermore intense. In "Objects of Desire," Charlesworth suggested how this super-fetishism developed from the moment of Pop to the emergence of postmodernism, in particular how it came to be focused on the presentational attributes of the media image—its saturated color and bright light, its luscious surface and brilliant shine.

5. Can Alienation be Desired?

"Objects of Desire" is not simply anti-fetishistic. Like Freud if not Marx, Charlesworth understood that fetishism will always play a part in our lives. Moreover, she was hardly opposed to visual pleasure; for Charlesworth, the watchword of 1970s feminism—that men possess the gaze while women are positioned as its objects—was a political caution, not an ontological truth; *Golden Boy* (1983–84), for example, is offered up for other kinds of admiration, both straight-female and gay-male. Charlesworth understood, too, that objectification is fundamental to art-making; her "Renaissance Paintings" and "Renaissance Drawings" (both 1991) reflect on the object language of bodily postures and gestures developed in that great era of art.

In fact, far from only anti-fetishistic, her work often makes fetishism look good, almost too good. Here Benjamin comes to mind once more. At the end of "The Work of Art in the Age of its Technological Reproducibilty," he wonders, with respect to Futurism, if technology has not changed the human sensorium to the point where mankind might regard its own alienation, even its own annihilation, as a source of aesthetic pleasure. If desire is alienated, can alienation be desired? In "Objects of Desire," Charlesworth re-posed that difficult question to the futurists of her own time.

6. Critique through Complicity

No one conveyed the ambivalence of the Pictures Generation regarding the media image—how we can be both seduced by it and suspicious of it—as directly as Charlesworth did. While many of us talked about the fuzzy area between complicity and critique, she delved into this difficult terrain. Again and again in her art, which is always as elegant as it is precise, Charlesworth staged our entanglements in the image for us—in part to delight in, in part to question—and often she did so in a way that we cannot tell these two activities apart.

If critique can come by way of complicity, so too does it emerge from commitment. Like some of her peers, Charlesworth liked to say that she was an artist who "used" photography. Yet this posture hid (albeit not well) a deep involvement in the medium, not only its commercial applications and media manipulations but also its historical variants and traditional genres. Her series

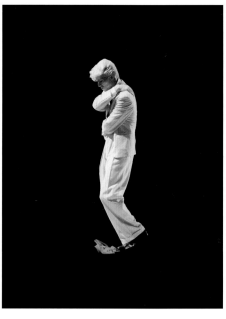

Golden Boy, from the "Objects of Desire" series, 1983–84. Cibachrome print with lacquered wood frame, 42 x 32 in (106.7 x 81.3 cm)

8. Walter Benjamin, "Paris, the Capital of the Nineteenth Century" (1935), in *The Arcades Project*, trans. Howard Eiland and Kevin McLaughlin (Cambridge, MA: Harvard University Press, 1999), 8. Freud published his classic text "Fetishism" in 1927, but the problem appeared as early as his "Three Essays on the Theory of Sexuality" (1905).

"Doubleworld" (1995) is an extended essay on questions of perspective, stereoscopy, illusionism, and still life. One feels that the title is also reflexive, a term for her own paradoxical practice, or practice of paradox, in which beauty and rigor, affect and analysis, and ambivalence and conviction are more complementary than contradictory.

7. Para-doxa

Doxa are ideologies that are so accepted as to be taken for truths; *para* means to stand alongside. This is where the paradoxical art of Sarah Charlesworth is located, and what it does: rather than simply oppose received ideas, it rubs up against them, making them shine and chafe at the same time. It is an art that looks great and hurts a little.

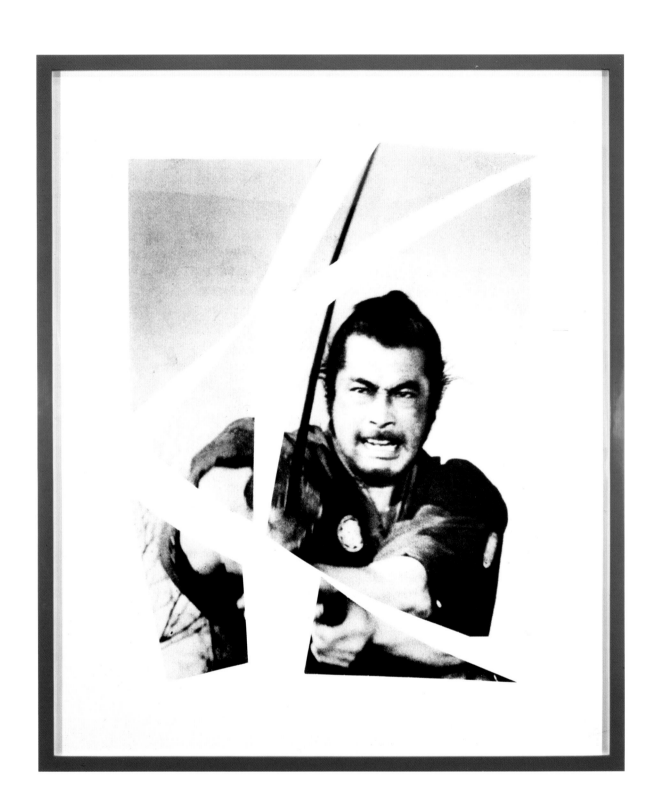

Samurai, from the "In-Photography" series, 1981. Black-and-white mural print, mounted with lacquered wood frame, 67 x 50 in (170.2 x 127 cm)

Artifacts of Artifice

Kate Linker

The work of Sarah Charlesworth is emblematic of the concerns of a postwar generation of artists, but it also occupies a special place among art practices using the medium of photography. While other artists have employed photography to address one or more issues related to a world that is increasingly dominated by images, Charlesworth was unique in making the photographic image her subject. In the image, Charlesworth found a subject at once inexhaustible and endlessly fulfilling. Her relationship to this subject was analytical, scholarly, and passionate, in the sense of what the writer Roland Barthes, whom she revered, would have called an "amatory" relationship. I have noted elsewhere that Charlesworth's entire oeuvre could be described as an intense and extended love letter to the photographic image.[1]

For Charlesworth, the nineteenth-century invention of photography irreparably changed the practice of art, ushering in expressive possibilities and opportunities for comment that were her generation's legacy and gift. From her first exhibited works that examine the construction of meaning to her last, which address the formation of the image through light, her art falls into discrete series or groups. This "series" function is important. Once, after I published an article about Charlesworth, a collector telephoned me to inquire which series he should buy from. I answered, "Buy a work from each!" My comment—a facile attempt to blow off a request and avoid responding to a question no critic should answer—nevertheless suggests the truth. Charlesworth's work must be seen in its entirety, in the range of questions she examined and the tantalizing material quandaries she raised as she explored the historical, cultural, and aesthetic body of the beloved photographic image.

The essay below was written in 1998 on the occasion of a traveling retrospective of Charlesworth's work organized by SITE Santa Fe and the National Museum of Women in the Arts, Washington, DC. It has been lightly adapted for this publication. Although it covers only work produced through the "Doubleworld" series (1995) and hence excludes Charlesworth's extraordinary late work, it suggests the seriousness, importance, and far-reaching resonance of the artist's unique endeavor.

—Kate Linker, February 2015

Sarah Charlesworth was nothing if not thorough. She graduated from Barnard College with a degree in art history, took studio art classes, read extensively in a range of disciplines, and, most significantly, experienced the 1960s transition from object-based Minimalism to dematerialized Conceptual art through studies with the Conceptual artist Douglas Huebler. Yet she also supported herself for seven years after graduation as a commercial photographer and took postgraduate courses with the fine-art photographer Lisette Model. She was therefore well situated to experience her generation's growing resistance to the purist culture of the art object and its acceptance of the outside world that photo-based "image culture" brought into art.

1. Memorial Service for Sarah Charlesworth, New Museum, New York, November 3, 2013.

Charlesworth's first works demonstrate the influence of photographic Conceptualism. Her undergraduate art history thesis—a fifty-print study of the architecture of the Guggenheim Museum that used photographs rather than written text to represent ideas—is indebted to her visit to one of the first shows of Conceptual art in New York, the exhibition of work by Robert Barry, Douglas Huebler, Joseph Kosuth, and Lawrence Weiner that Seth Siegelaub organized in a rented space on 52nd Street in 1968. By her own account, she spent much of the 1970s searching for her own voice, drawing on Conceptualism's demand that artists reflect critically on their practice and acknowledging both art's internal dialectic and the external ground of social and economic conditions. In 1973, while researching the "historicity" of photography as embodied in turning points in human history, she discovered a daguerreo-type containing an image of the first person known to be photographed— a solitary man having his shoes shined on a Parisian boulevard. Because of the long exposure time, the figure registered in strong, dark tones, standing out sharply from its blurred surroundings. Charlesworth isolated the figure, enlarged it, and printed it as a silkscreen, producing an image that, she said, "felt right." The image is a harbinger of key features of Charlesworth's work— a constellation of time, technology, cultural immanence, and personal reflection.

With Joseph Kosuth and several colleagues from the New York group Art & Language, Charlesworth founded and edited *The Fox*, a landmark maga-zine devoted to art theory. *The Fox* survived for only three issues, published between 1975 and '76. It is a remarkable document: behind the infighting, the often-labored language, and yawn-inducing syntax lies a radical sense of historical urgency. In one of Charlesworth's contributions to the first issue, titled "A Declaration of Dependence," she describes art's new dependence on social or historical conditions, opposing it to the supposedly autonomous and inner-directed world of aesthetic modernism. Arguing for a materialist practice that assumes an intimate relationship between artist and culture, Charlesworth criticizes by-then-attenuated Conceptualism for "*function[ing] in society*" like one "commodity-product" among others.[2] Elsewhere, Charlesworth tucked a cryptic comment into the pages of the final issue of *The Fox*: "Twentieth-century battles cannot be fought, I suspect, according to Victorian battle plans."[3] With succinct language, she declares an end to the nineteenth-century tradition of the avant-garde and marks the "historicity," or radical immanence, of the photographic image to contemporary culture.

"Modern History"

Charlesworth's first work exhibited in an art context was an extended series that was titled "Modern History" (1977–79). The works operate through a simple displacement—newspaper images and graphics transferred to a gallery setting—that is seconded by the replacement of written texts by white space, so as to emphasize the visual rhetoric of the images. Collectively, they appear as tactical interventions animated by a broader strategy: to examine and rep-resent the role played by photographic culture in the making of contemporary history. Here, the quotational approach of Charlesworth's earlier daguerreo-type experiment is set in motion.

"Modern History" reflects the view, common during the late '70s and early '80s, that history is a kind of fiction, its meaning dependent on the multiple

Cover of *The Fox* 1 (1975). Editors: Sarah Charlesworth, Michael Corris, Preston Heller, Joseph Kosuth, Andrew Menard, and Mel Ramsden

2. Sarah Charlesworth, "A Declaration of Dependence," *The Fox* 1 (1975): 5.
3. Sarah Charlesworth, "For Artists Meeting," *The Fox* 3 (1976): 41.

factors that surround the interpretation of any event. *April 21, 1978* (1978), part of the so-called "Moro Trilogy," is among the best-known works in the series. Composed of forty-five black-and-white prints, it relentlessly chronicles the media representation of a specific event—the kidnapping and assassination of the Italian prime minister Aldo Moro by the terrorist group the Red Brigades. During one day of Moro's fifty-five-day captivity, Charlesworth collected the front pages of many international publications, then cut out everything except the mastheads and photographs, retaining their size and disposition on the pages. Charlesworth's prints keep the scale of the newspapers, with pictures and boldly accented typography visible in syncopated rhythms against white grounds. The result is a striking demonstration of the varying emphasis that the media accords to different news events and of the way that emphasis can shape the opinion of the reader/viewer. By examining the role of specific editorial decisions—placement of images, cropping, sizing, and so forth—in establishing the official record and meaning of an event, *April 21, 1978* undermines the presumed factuality of the photographic document. Charlesworth's intentions are underscored by the internal play of the historical narrative. The previous piece in the trilogy, *April 20, 1978* (1978), details the fake announcement of Moro's assassination that the Red Brigades had purveyed to the press on April 20. The panels from the following day's newspapers bear an image provided by Moro's captors: it shows the politician holding the previous day's edition, its headline proclaiming his death. The Red Brigades' message—"Just kidding..."—demonstrates the manipulation of meaning that surrounds the use of any photograph.

As a series, "Modern History" offers a sharp retort to the modernist view that meaning is resident in an artwork as its inhering attribute or core. In this, Charlesworth shares much with other artists of the period—Louise Lawler, Sherrie Levine, Richard Prince, and Cindy Sherman, among them—who were examining the conceptual and contextual dimensions of the use of images. However, Charlesworth's early work is distinguished by its near-obsessional character and by the rigor of its internal structure, with each group of works in "Modern History" developed according to an individual set of rules or game plan.

"Stills" and "In-Photography"

In 1980, Charlesworth produced an extraordinary series of large-scale black-and-white prints of men and women plunging from windows, either trying to save themselves from burning buildings or committing suicide. Again using pictures appropriated from news sources and again resulting from extensive picture research, the works employ a title purposely taken from film vernacular: "Stills." The individual titles are at once cryptic and descriptive—*Unidentified Woman, Hotel Corona de Aragon, Madrid* or *Unidentified Man, Ontani Hotel, Los Angeles*, for example. The deadpan mood offers a flashback to Warhol's "Death in America" and "Death and Disasters" series from the early 1960s, showing the importance of the Pop heritage for the generation of the 1980s. Each work depicts a singular, undefined, ephemeral event that is ripped from the narrative continuum that might "explain" the image. No caption informs us of the outcome of these events. We know nothing about the private histories or intentions of the protagonists, and even our tendency to see them

as what they are—death scenes—is subverted by the equivocal beauty of the tonal studies of falling forms, eerily suspended in space. The "Stills" series sets up a contrast between the incompleteness of the depicted moment and the integrity of the photographic object, between its inadequacy as a substitute for its subject and its hallucinatory affective power.

Indeed, Charlesworth's art of 1980 through '82 displays a love-hate relationship with the photographic referent. In these works, which dispense with photographic illusionism through increasingly abstract means, reality is presented as the "vanishing point" of the image. Charlesworth is less concerned with the photograph's documentation of its subject than with the photograph as a subject in itself. A series from 1981 and '82 called "In-Photography," a counter to Susan Sontag's 1977 book *On Photography*, uses the photographic surface as a seductive veil masking its referent—not a transparency, but rather a screen. In some works (*Samurai* [1981]) the surfaces are slashed and scarred; in others (*Rietveld Chair* [1981]) they are imprinted with negative images of their subjects; in yet others, the print surface is rendered like a skin that peels back to reveal the distant image that is the work's ostensible subject. Charlesworth described "In-Photography" as evoking the "meeting of an object and its apprehension." The series displays the main characteristics of the artist's mature work—radically truncated or excised images, elaborately worked surfaces and frames—that call attention to the photograph's status as a construction rather than a re-presentation of the real. The surface is an elaborate lure to entice the viewer, beckoning him or her as if through a mirror, toward a referent that may be unrelated to the photographic image.

Charlesworth's work of the early 1980s has affinities with that of her contemporaries who were examining the artistic production of meaning, observing how institutions and conventions, along with the material practices of art, structure the "speech" of art. It was a time of heady debates, when many of the signal themes of postmodern theory—originality, authorship, seriality, repetition—were transported into aesthetic discussions. For Charlesworth, an important influence was the writings of Roland Barthes, which were first translated from French and disseminated to an American audience during the 1970s. Barthes's heralding of the transformation "from work to text" and his trumpeting of the suspension or "disappointment" of meaning were not lost on a generation bent on dismissing the model of fixed or "meaningful" art that they had inherited.

Charlesworth's work as a whole parallels the remarkable range of Barthes's interests and personae. In it, one finds echoes of Barthes the cultural mythologist and semiologist; Barthes the critic of the notions of authorship and originality; Barthes the "readerly" writer and protagonist of response, whose reactions to mundane objects or images elicited voluminous commentaries of intricately reticulated thought; and, not least, Barthes the obsessional analyst of "The Photograph." In an April 1982 *Artforum* review of Barthes's *Camera Lucida* (1980), Charlesworth singled out his discussion of Joseph Nicéphore Niépce's 1829 photograph of a dinner table (which he misidentifies as the "first photograph"). "The Niépce dinner table," she observed, "is also one of my favorites."[4]

The Niépce photograph is the subject of her series of silkscreens "Tabula Rasa," made in 1981, prior to her reading of Barthes's book. Technically speaking, the image is a copy of a lost original; our knowledge of the photograph is

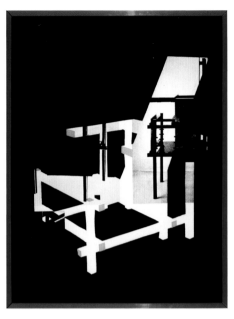

Rietveld Chair, from the "In-Photography" series, 1981. Black-and-white mural print, mounted with lacquered wood frame, 68 x 50 in (172.7 x 127 cm)

4. Sarah Charlesworth, "Sarah Charlesworth on *Camera Lucida*," *Artforum*, April 1982, 72–73.

derived from a degraded half-tone reproduction of it made in 1891. The dinner table image was an apt subject, not only for Charlesworth's commentary on photography, but also for the discussions on originality of the 1980s, inasmuch as Barthes constructed an elaborate fantasy of origin around it. Charlesworth made four "original" silkscreen prints that are copies of Niépce's still life, enlarging it to six by eight feet and rendering its hazy half-depiction in ghostly, white-on-white tones—each print differentiated only by a small red stain in one corner. They are images of evanescent and tantalizing beauty, notable more for the subjective stirrings they incite in the viewer than for the specific objects they depict. Charlesworth points to the dynamic of her discourse on origins by silhouetting a white fifteenth-century Flemish Annunciation lily in one corner of each print—an oblique allusion to Barthes's influential dictate that "the birth of the reader must be at the cost of the death of the Author."[5]

"Objects of Desire"

The series "Objects of Desire" that Charlesworth produced from 1983 to 1988 inserts itself into the postmodern examination of photographic culture that infused much '80s art. Drawing on the appropriationist strategies developed in the previous decade, the series entailed the use of images drawn from the mass media and an investigation of their effects. The notion of mediation that was tossed about during the decade was a response not only to the global distribution of media images (the "image culture" of postwar society), but also to the growing role played by images in every aspect of daily reality.[6] The sense that representations "subject" their viewers, creating ideologies and roles, as much as they render or depict their subjects is particularly strong in critical projects that feminist artists developed during the period. Charlesworth's art should be interpreted alongside the art of Barbara Kruger, Cindy Sherman, Laurie Simmons, and other women who, in different ways, attempt to examine and intervene in the production and reproduction of social and sexual norms. At the core of this enterprise was less an examination of what photographic images are or look like than what they do.

"Objects of Desire" displays Charlesworth's hallmark devices. Photographic images taken from a variety of sources—fashion magazines, pornography, and geographic circulars, among others—are excised from their contexts and rephotographed against bright, laminated, monochrome backgrounds; the resulting prints are then bound by lacquered frames. The paring away of contextual incident abstracts the images from any narrative. The central placement of the image, its surrounding color, the glossy Cibachrome surface, and austere format are rhetorical devices intended to deflect attention away from the objects depicted to the photograph as a whole.

The word "desire" in the series title has several meanings. Used generally, it is a marker for our human attraction to the seductive properties of objects. It also refers, more specifically, to the psychoanalytical sense of desire as loss, a consequence of our human condition, which impels a continual longing for wholeness. Viewed through this lens, many images act as fetish objects, offering illusions of unattainable unity to the psyche.[7]

Organized in five parts, "Objects of Desire" reflects Charlesworth's ambition to present a kind of "grammar of experience." The depicted objects are all derived from a carefully accumulated and catalogued image repertoire.

5. Roland Barthes, "Death of the Author," in *Image-Music-Text*, ed. and trans. Stephen Heath (New York: Hill and Wang, 1977), 148.

6. This sense of the constructive role of representations informed many exhibitions of the 1980s, from the early "Image Scavengers: Photography" at the Institute of Contemporary Art, Philadelphia, and "In Plato's Cave" at Marlborough Gallery, New York (both 1982), to the 1989 "A Forest of Signs: Art in the Crisis of Representation" at the Museum of Contemporary Art, Los Angeles, and "Image World: Art and Media Culture" at the Whitney Museum of American Art, New York.

7. Most directly, Charlesworth's use of the term is a gloss on Douglas Crimp's definition. In his landmark 1977 exhibition "Pictures," he describes the picture as "an object of desire, the desire for the significance that is known to be absent."

Charlesworth's zeal in assembling and selecting these images seems half anthropological, half semiotic.

The first part of the series (1983–84) deals with sexual or gender-coded imagery—a wispy chiffon scarf, a mask, a bombshell-blond shock of hair—that recalls the '80s fascination with sexualized glamour. Emblematic images, their subjects' faces and appendages excised, are presented as if empty shells against glistening red and black fields. In conversation, Charlesworth described the images as presenting "the postures of seduction—the shapes, forms, or gestures that are the exterior trappings of identity."[8] They provide non-didactic examples of the view that sexuality is imposed externally through representations, like a mask or cover concealing a void.

In the second part (1985–86), attention is directed to the concept of the natural. An owl, a snake, a goat crowned with flowers—all taken from geographic or travel magazines—are silhouetted against green or black grounds. This is nature as fantasy or myth, as it appears in our global imaginary.

The spectacular brilliance of the laminated surfaces in "Objects of Desire" has spurred analogies with mirrors—so much so that certain critics, myself included, have likened them to instances of the psychoanalyst Jacques Lacan's notion of the mirror stage. The analogy is unfounded: Charlesworth's surfaces are opaque, her knowledge of Lacan scant. Instead, the vitreous quality is bound up with her definition of the photograph as an object with visual effects, one whose mesmerizing surface functions as a challenge to the observer's urge to find meaning.

The gap between the irresolution of meaning and the viewer's insistent desire for closure is the theme of the third part of the series (1986), which addresses social and religious images—gods, figureheads, icons. Gold functions as an emblematic signifier (*Bull* [1986]), and an exaggerated central placement of images yields hieratic forms of static power. In *Lotus Bowl* (1986), a work inspired by Charlesworth's long-standing interest in Buddhist culture, the juxtaposition of two images—one above the other—yields a meditative token: a lotus flower hovering enigmatically above a religious vessel.

The juxtaposed figures of "Objects of Desire" form an experiment in basic visual syntax, developed in analogy with the linguistic premise that words placed against words elicit meanings. Images are apposed in contrasting panels (*Bowl and Column* [1986] and *Buddha of Immeasurable Light* [1987]) or in triptych-like formats composed of rephotographed images that are intercut by a monochrome panel (*Natural History* [1987]). The result is an indeterminate space with equivocal meanings, somewhat like a dreamscape or oneiric field. Still, the fourth part of the series (1987–89) examines limits to the viewer's urge to assign meanings to images. For example, in *Bowl and Column*, two glistening objects—one tall and elongated, the other short and squat—are positioned in separate, deep blue fields. Any decoding of the column and bowl as male and female symbols, Charlesworth suggests, is a projection of the viewer—an effort to "ascribe" meaning or "locate" reference based on photographic effects rather than attributes.

"Academy of Secrets" and "Renaissance Paintings"

In Barthes's *Camera Lucida*, photographic experience is presented as a relationship between three terms: the "Spectrum" (the subject or referent),

8. David Deitcher, "Questioning Authority: Sarah Charlesworth's Photographs," *Afterimage* (Summer 1984): 17.

Subtle Body, from the "Academy of Secrets" series, 1989. Cibachrome print with lacquered wood frame, 78 x 57 in (198.1 x 144.8 cm)

9. Giovanni Battista della Porta, *Natural Magick* (London, 1558), as cited in Jonathan Crary, *Techniques of the Observer: On Vision and Modernity in the Nineteenth Century* (Cambridge, MA: MIT Press, 1990), 37.

the "Operator" (the photographer), and the "Spectator" (the viewer). This triangular composition also structures Charlesworth's practice, although her emphasis varies at different moments. In the works leading up to and including "Objects of Desire," attention is directed primarily to the role of the Spectator. In three succeeding series, "Academy of Secrets" (1989), "Renaissance Paintings" (1991), and "Renaissance Drawings" (1991), Charlesworth concentrates on the Operator, or what might be called the subjective dimension of the artist.

The mood, tenor, and physical demeanor of these series shift away from analytic rigor toward a soft, almost elegiac tone as the artist confronts a deep-seated need to address personal feelings. Charlesworth has described "Renaissance Paintings" as "extremely emotional work," crafted through the more visible "manipulation of cultural things." The title "Academy of Secrets" refers to Giovanni Battista della Porta, the sixteenth-century Neapolitan nobleman who is reputed to have invented the first camera lens. In his treatise *Magiae Naturalis* [Natural Magick] of 1558, della Porta describes an early camera obscura, significantly indicating that our means of organizing knowledge may determine the extent to which we see things. "We are persuaded that the knowledge of secret things depends upon the contemplation and the view of the whole world," he observed.[9] What is less known, however, is that della Porta was the master of a clandestine society dedicated to the notion, considered heretical at the time, that nature's laws might be independent of God's. Della Porta's conjunction of seemingly opposite terms—secrecy and science, hidden magic and technological innovation—appealed to Charlesworth, who had long been interested in magic and the occult. In "The Academy of Secrets," the concepts are fused: "secrecy" alludes to the inner, unknown life of the psyche, while the organized or "scientific" structure denoted by the title refers to established or codified knowledge. The relationships between the two categories are mediated by an approach loosely based on Freudian psychoanalytic theory, particularly its notion of the dream.

Symbolically weighted images—hearts, lotus blossoms, and wombs, for example—are arranged in luminous monochromatic fields of red, yellow, black, and white. The images are either disposed loosely over the surfaces as if in a dreamspace, or aligned vertically (*Subtle Body* [1989]), suggesting the anthropomorphic format of portraits. Many works use occult religious symbols. *Subtle Body*, for example, appropriates the format of Tantric meditative emblems that arrange images along the human body's vertical axis. The mystical symbols are replaced by images with personal significance for the artist. The progression of the images—a snail, a heart, a pitcher, among them—moves from earthly matter to an implied spiritual transcendence. The objects in *Subtle Body* often have hard shells or firm contours that suggest an inner world hidden beneath an exterior.

This structure of outside and inside, or disclosure and secrecy, reflects an analogy by which the physical body serves as a metaphor for the inner, "psychic" body or unconscious. One piece, *Temple of My Father* (1989), presents a mini-anthology of objects symbolizing Western concepts of masculinity—a collection not different from the ancient artifacts that Freud amassed. Not unexpectedly, several works are self-portraits. In *Of Myself* (1989), the physical body is dismembered and dispersed within a broad red field against which images or symbols read like shifting constellations. In *Self Portrait* (1989), the human form provides an armature supporting fragmentary clay votive fetishes

in the shapes of organs (eye, ear, hand, breast, foot). These objects are symmetrically disposed in a yellow field that centers on a bulbous urn—an allusion to the artist, who was pregnant at the time the work was made.

Discussing her work from 1989 to 1991, Charlesworth remarked that the symbolism of its images reflects "a level of unconscious engagement in language."[10] Her comment alludes to the psychoanalytic notion that the unconscious is structured like a language that surfaced in art discourse in the 1980s. Language-like play also accounts for interpretative plurality. In "Renaissance Paintings," the imagery of Italian Renaissance art is appropriated, abstracted from its context, and broken down into individual components that are rearranged by the artist. The interlinking chains of images that result impel personal but open-ended narratives evoking strong emotions—longing, loss, madness, fear. Charlesworth's aim here is not didactic; the viewer's eye may wander freely, ricocheting through space, and pursue whatever relationships it will.

"Natural Magic" and "Doubleworld"

The "Academy of Secrets" and "Renaissance Paintings" series represent a specific moment in Charlesworth's practice, marked by an eruption of subjectivism that contrasts with the dominant analytic cast of her oeuvre. By the time of the "Natural Magic" series (1992–93), the persona of the artist had shifted to that of a magician, who performs illusions or sleight-of-hand routines that are photographed by an assistant. Here, in a play on the norms of photographic veracity, Charlesworth learned a group of magician's tricks and documented her enactment of these skills; the outcome is artifice masquerading as nature, fiction purporting to be real.

The title of the "Natural Magic" series involves flashbacks both to della Porta's book and to the sense of wonder that surrounded the invention of photography. A levitating woman (*Levitating Woman* [1992–93]), an array of cards poised precariously in the air (*Control and Abandon* [1992–93]), and a genie's lamp that discharges cotton candy-like smoke (*Materialization* [1992–93]) figure among the works' subjects. *Trial by Fire* (1992–93) shows Charlesworth juggling flames, her hands clad in white gloves. Dave Hickey has written that these "photographs of magic tricks in progress…are lovely jokes since, simply by virtue of their being photographs, they tell us nothing at all about the magic tricks and everything about the photograph."[11] They tell us, in other words, about the role of conventions, orientation, and captions in the perception of photographic space. The images are set in black grounds and sized in oval formats so that they occupy an ambiguous territory between photographic portrait frames and tondo-shaped canvases. Photography, the artist seems to suggest, is as much an art of illusion as painting. Its purchase on the real is overrated.

The scope of Charlesworth's critical comment is evident in "Doubleworld" (1995). In this eight-work series, her attention is not directed to photography per se, but rather to vision; her focus is on our construction of reality through the modalities of sight rather than the photographic constitution of an image. All of the works address the convention of the still life, adapting its notion of "stilled life" or "dead nature" (nature morte) to photography's inherent immobilization of time. However, the major source for Charlesworth's imagery and

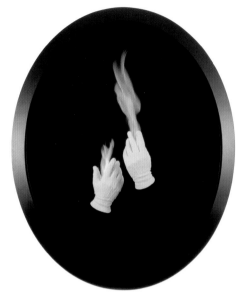

Trial by Fire, from the "Natural Magic" series, 1992–93. Cibachrome print with lacquered wood frame, 41 ¼ x 31 ½ in (104.8 x 80 cm)

10. "Sarah Charlesworth," interview by Betsy Sussler, *BOMB* 30, Winter 1990, 30.
11. Dave Hickey, "A Matter of Time: On Flatness, Magic, Illusion, and Mortality," *Parkett* 40/41 (1994): 168.

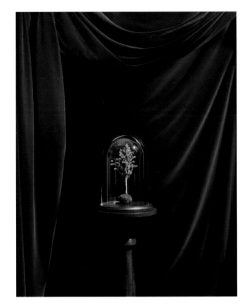

Homage to Nature, from the "Doubleworld" series, 1995. Cibachrome print with mahogany frame, 51 x 41 in (129.5 x 104.1 cm)

12. Charlesworth's understanding of the organization of vision in the nineteenth century, like my own in these pages, was influenced by Jonathan Crary's *Techniques of the Observer: On Vision and Modernity in the Nineteenth Century* (Cambridge, MA: MIT Press, 1990).

presentational devices is the photography and salon-type painting of the nineteenth century. The elaborate props and opulent textures that were hallmarks of the era offered a feast for the eye to a century newly attuned to consumption and are adopted here in photographic tableaux. The nineteenth century is chosen as the period when the subjective dimension of vision—its embodied and culturally mediated character—first began to be studied in an organized way.[12]

Although only one work, *Allegory of the Arts* (1995), is given a title that overtly points to allegories of vision, all the images in "Doubleworld" can be construed as such. In each, an elaborate composition of objects—violins, palettes, Greek portrait busts, fruits, and flowers, among others—is arrayed against a background of luxurious velvet drapes. The glistening surfaces and lush textures, along with the artificial perfection of the compositions, designate these works as intended for the delectation of a viewer who takes pleasure in their allure, an active viewer who finds meaning in the interface established between the objects and the gaze. This aspect is emphasized by Charlesworth's use of riddling configurations that function somewhat like rebuses. Chains of images, bound together as if by invisible links, urge the eye to decode them in its quest for meaning.

Charlesworth directs our attention to the role played by vision by placing nineteenth-century optical devices in several photographs. In *Still Life with Camera* (1995), it is a box camera; in the coyly titled *Untitled (Voyeur)* (1995), a brass telescope poised on a viewing stand pokes through a velvet curtain. The print *Doubleworld* (1995) shows two stereoscopic viewing devices holding identical images of two women. The nineteenth century's optical experiments, Charlesworth suggests, shaped the visual perceptions of the observer, and, in a related manner, our contemporary sense of "natural" vision is bound up in its historical construction. By extension, our access to an object is never pure, absolute, or objective, but instead is refracted by historical vectors and points of view. The box camera and its roundelay of objects in *Still Life with Camera* occupy separate frames, divided and "doubled" worlds.

The insistent, obsessional character of Charlesworth's approach in "Doubleworld" is summed up in one photograph: *Homage to Nature* (1995). A miniature pine tree, contained by a glass bell, is placed on a mahogany stand and set against an elaborate forest-green velvet drape. The image symbolizes the value we confer on ideas as well as objects. Nature is presented as a precious artifact whose worth is produced by culture. However, inasmuch as Charlesworth is presenting a vision of nature, she can also be assumed to be addressing "natural" vision and declaring that it, too, is an artificial construction. This view is supported by other details in the work. By proposing an analogy between the glass globe and the frames of her photographs, she declares that the photograph, like other art forms, is an artifact; it cannot be seen as a window on the world, a slice of life, a transparency giving onto meaning. Instead, it is another metaphysical bubble, another constructed form that contains our visions and desires within historical bounds. Using unerring tact and impeccable focus, Charlesworth sums up a generation's concerns with a whisper.

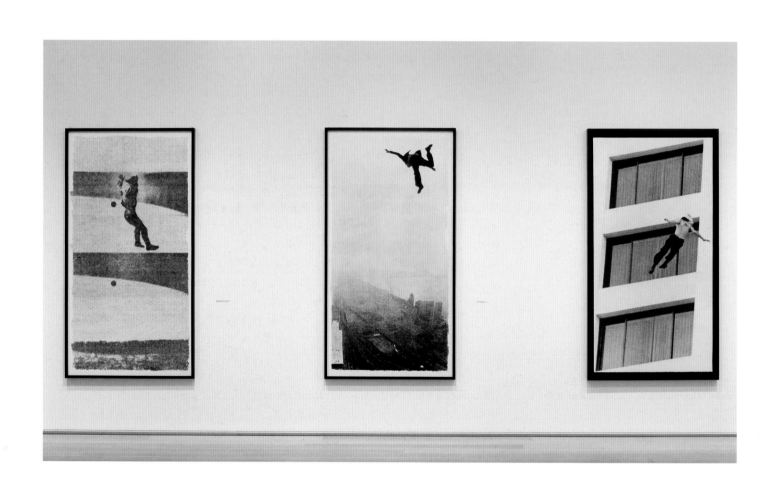

"Stills" series, 1980, printed in 2012. Installation view: "Sarah Charlesworth: Stills," the Art Institute of Chicago, Gallery 188, September 18, 2014–January 4, 2015. Photo © the Art Institute of Chicago

At Eye Level

Johanna Burton

To kick off a 1980 conversation with Sarah Charlesworth, editor and critic Betsy Sussler posed what would initially seem to be a truly wild-card question: "Do you have flying dreams?"[1] "What a question!" the artist exclaims, but then gamely confirms that yes, in fact, she dreams of flying often, and that these comprise her "best dreams…. They are like power dreams. Power, not in the sense of power over, more like the power of becoming, of possibility."[2] In fact, she asserts, flying might symbolize "the exhilaration of moving beyond what we normally conceive of as possible and impossible."[3] As readers move further into the interview, the (perverse) logic of Sussler's line of inquiry starts to make sense; the discussion revolves around Charlesworth's then-current exhibition, a presentation of seven large-scale photographs at Tony Shafrazi's gallery (at the time, the young dealer's East Village living room) in New York. The series, titled "Stills" (1980), utilizes found images—collected by Charlesworth from the New York Public Library and various news wire services—of people leaping, presumably, but not certainly, to their deaths.

Pulled from media outlets that utilized low-grade image quality in order to facilitate high-quantity circulation, the source materials for "Stills" started out degraded. Charlesworth amassed some seventy small, pixelated, gray-scale pictures from which she eventually selected seven for her show at Shafrazi's gallery, extracting them from the informational and/or sensational contexts in which they were first presented, then rephotographing and enlarging them so their overall compositions were more or less "life size" at six-and-a-half-feet tall.[4] The resulting effect is one of proximate distance: the existential fact of bodies halted by the photographic apparatus is clear enough, but details beyond that are literally obscured. Whether "unidentified" or titled by way of the jumper's proper name, the subjects here are rendered anonymous, obscured not only by the limits of the original images themselves but, ironically, by Charlesworth's impulse to bring them closer via magnified scale. Indeed, for however strangely *personal* each image is (in the same way that each of us has a signature gait, a habitual way of holding our head, it appears we all assume distinct postures during free fall), the subjects pictured therein embody the very condition of erasure. One realizes, looking at "Stills," that they operate in equal parts indexically and metaphorically: here are disappearing images of people disappearing. One might say, to follow this line of thinking, that the blunt materiality of these images of utter devastation is matched only by their poetic thrust. They flicker between presence and absence, life and death, movement and arrest.

What was important for Charlesworth, however, was that her collection of jumpers was hardly cut from the same cloth. Indeed, as she made sure to note in more than one discussion about the series, while the visual *effect* of the resulting images suggests affinity within a shared action, the impulse and

1. "Dialogue: Sarah Charlesworth with Betsy Sussler," *Cover* magazine, Spring/Summer 1980, 23–24.
2. Ibid.
3. Ibid.
4. Charlesworth did not employ a single standard of treating the images. Some were cut cleanly, with a blade, while the majority retained evidence of being torn out by hand. In addition, while the original show at Shafrazi's gallery included seven total works, Charlesworth was working with a collection of seventy potential images. Many years later, returning to this pool, she produced an additional "Still" as a 2009 commission for MAMAC (Musée d'art modern et d'art contemporain) in Nice, France, and brought the total number of "Stills" to fourteen when the Art Institute of Chicago asked her, in 2012, to produce the definitive set for their collection. For more on the history and evolution of the series, see Matthew S. Witkovsky, ed., *Sarah Charlesworth: Stills* (Chicago and New Haven: Art Institute of Chicago and Yale University Press, 2014), which includes an essay by Witkovsky dedicated to the "Stills" series and a conversation between Witkovsky and Matthew C. Lange, who worked extensively with Charlesworth and now helps organize her estate.

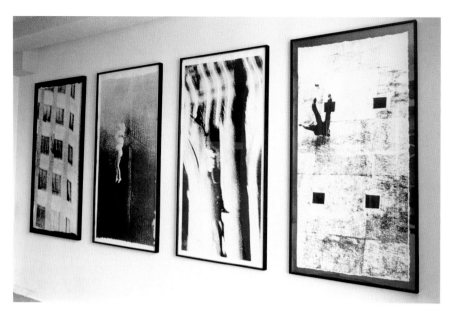

"Stills" series, 1980. Installation view: "Sarah Charlesworth: Stills," Tony Shafrazi Gallery, New York, February 14–March 5, 1980. Photo: Sarah Charlesworth

aim of the jumps were crucially distinct: suicides, yes, but also people trying to jump to safety—to save themselves, that is, say, from fire—as well as an occasional stunt jump (though the artist came to find these least interesting and most contrived) and a few situations in which the intention and motivation will simply never be known.[5] Charlesworth, in other words, notes that formal operations and the images that result from them must also be accounted for in terms of their interior construction (emotional, psychological, practical)[6]; this is crucial to understanding not only "Stills," but also the artist's more than thirty-year career. So many characterizations of advanced art from the '70s and '80s describe the milieu of which Charlesworth was a part—often referred to as the "Pictures Generation"—as doing away with conceptions of and attention to depth and privileging, instead, surface and simulacrum. For this reason, among others, the artist largely rejected the term "postmodernist" with regard to her own practice, complaining that it served merely as a "convenient catch-all term used to refer both affirmatively as well as pejoratively to the entire random, erratic spectrum, the eclectic free-for-all, that has marked artistic practice since the early 1970s...."[7]

Leaving aside, for the purposes of this essay, the much- and long-debated terrain of just what postmodernism was, it is worth noting Charlesworth's suspicion of it, as well as her admission, over the years, that she still felt tied to legacies of modernism, even if she was working in the medium—photography—that ostensibly overturned modernism's commitment to art forms (such as painting and sculpture) that could be understood as standing apart from the larger (i.e., mass) culture.[8] "To live in a world of photographs is to live in a world of substitutes—stand-ins—representations of things, or so it seems, whose actual referents are always the other, the described, the reality of a world once removed," Charlesworth writes, summarizing the prevailing logic around photography in the early '80s. "I prefer, on the other hand," she continues, "to look at the photograph as something real and of my world—a strange and powerful thing—but not a thing to be viewed in isolation, but as part of a language,

5. See, for instance, the artist's comments on types of jumpers in "Dialogue: Sarah Charlesworth with Betsy Sussler," 23–24.

6. To this end, it's worth noting the many formal connections to be made with Charlesworth's "Stills." In her own immediate context, one can point to Jack Goldstein's work—*The Pull*, from 1976, a triptych of photographs with three isolated figures: a spaceman, a deep-sea diver, and a free-floating figure, ambiguous but often read as a suicide; and *The Jump* from 1978, a video piece in which the artist used rotoscoping to isolate and abstract a gymnast's leaps into an endless loop. One also thinks of Robert Longo's "Men In the Cities" (1979–82), in which a single moment in a Rainer Werner Fassbinder film (that of a man being shot in the back) offered a strategy for producing a series of drawings. Closer to our own present, Charlesworth's "Stills" works have been invoked as eerie predecessors to images circulated in the press documenting people thrown from or jumping out of the Twin Towers on 9/11. And looking back, one cannot but recall Yves Klein's canonical 1960 *Leap Into the Void* (not incidentally, this work is illustrated in Charlesworth's syllabus for "Photographies," the class she developed for Princeton). Yet, for however resonant the aesthetic aspects of these and other works that take the human body in flight as subject, they underscore Charlesworth's point that no two can be equated.

7. Charlesworth, "Post-Modernism and Photography," panel paper, Society for Photographic Education, Philadelphia, March 1983; reprinted in this volume, 96.

8. "Postmodernist" practices were argued, by postmodernism's most adept theoreticians, as necessarily dialectical. Craig Owens, for instance, defined postmodernism as characterized by a "desire to embed a work in its context." Yet, for its potential to deliver radical reflexivity of this kind, Owens conceded that postmodernist *style* was often commandeered as a novel cover for ultimately conservative works of art. Douglas Crimp, too, explored the ways in which the ostensibly groundbreaking porosity between mediums born of postmodern art might be recuperated for traditional ends, ultimately reifying the very foundation against which they would seem pitted. And Hal Foster overtly tied together two sides of a postmodernist coin, "one aligned with neoconservative politics, the other related to poststructuralist theory." Seminal books on the topic include Craig Owens, *Beyond Recognition: Representation, Power, and Culture* (Berkeley, CA: University of California Press, 1992); Douglas Crimp, *On the Museum's Ruins* (Cambridge, MA: MIT Press, 1993); Hal Foster, *Recodings: Art Spectacle, Cultural Politics* (Port Townsend, WA: Bay Press, 1985); and Hal Foster, ed., *The Anti-Aesthetic: Essays on Postmodern Culture* (Port Townsend, WA: Bay Press, 1983).

April 21, 1978 (detail), from the "Modern History" series, 1978. Forty-five black-and-white prints reproduced at the same size as the original newspapers, dimensions variable, approximately 22 x 16 in (55.9 x 40.6 cm) each

9. Charlesworth paper, 98.
10. Ibid. Reflecting on the way we receive information—via television, movies, and photographs—in an increasingly global, mediatized world, Charlesworth remarked that "These images are the things of which my psychic environment is made, perhaps even more than the tables and chairs that make up the physical architecture of my personal world."

a system of communication, an economy of signs."[9] In this statement, the artist places one foot in each camp: her commitment to the semiotic potential of representation firmly postmodern in tenor, steeped in an often-remarked-upon commitment to feminist critiques of representation; and her insistence on the photograph in and of itself as an unlikely modernist object, able to access and produce self-reflexive interiority. ("*Art is not defined by the medium it employs but rather by the questions that it asks,*" Charlesworth emphasized, "by the propositions that it makes regarding its own nature as well as the nature of its world."[10])

It is in this regard, I think, no accident that the first series Charlesworth became known for, begun three years prior to "Stills," was titled "Modern History" (1977–79). This body of work also utilized newspaper imagery and tracked a number of events over time and context. The most famous iteration is the forty-five-print work *April 21, 1978* (1978), which centers on a single image of Aldo Moro, the Italian prime minister kidnapped by the Red Brigade, here seen holding a dated newspaper proving he was still alive (though not for long, since he would be killed a few weeks later). Removing all text save the masthead, Charlesworth maintained the size and shape of each discrete newspaper, presenting a global account, over the course of a single day, of a world event. A viewer "reading" the text-free papers had no choice but to confront the way in which any given culture accounted for and ranked Moro's situation. Not surprisingly, for instance, the Italians featured the image on the front page of their paper; in London, on the other hand, the story was superseded by a picture of Queen Elizabeth holding her new grandson. Yet rather than learning anything substantial here about the priorities of the American press, say, versus that of the Swedes, one was reminded of the overarching power of visual arrangement—anything but arbitrary, the newspapers' pictorial compositions reveal conscious and unconscious priorities and repressions playing out in the daily news, manipulating a public's ideas and values via an ostensibly random selection of images arranged on a page.

The works within the "Modern History" series focused on Moro are politically forceful and trace the literal recognition of underground activity overthrowing sanctioned power. But Charlesworth seems to want to remind us that the politics of and in representation are just as present and evident in seemingly neutral forms. In *Arc of Total Eclipse, February 26, 1979* (1979), another work in "Modern History," Charlesworth tracks an event not over a single day, but as it literally moves across space. Following an eclipse via the front pages of newspapers covering its course through the US, Canada, and Greenland, *Arc* makes the obvious but profound point that no two people ever see the same object or, perhaps better, that every image is the result of a convergence between the seeing and the seen. Charlesworth's series title "Modern History" brings together, as does her definition of photography, a competing clause: "modern" was, when she was titling the work, a demarcation reserved for a period of art and culture that many believed had effectively come to a close; yet, etymologically—and, in fact, in common parlance—"modern" is just another word for "today."

To assess Charlesworth's position in her own then-contemporary—and now historical—context, it is worthwhile to consider her 1982 remark:

[s]ometimes I open an image in order to make room for myself, to disrupt the closure of an intensified unknown. The entry into an image, the

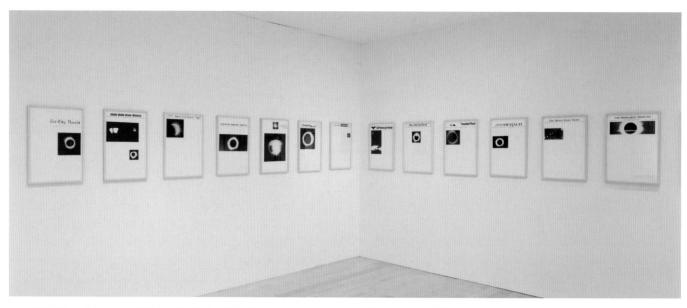

Arc of Total Eclipse, February 26, 1979, from the "Modern History" series, 1979. Installation view: "Singular Visions," Whitney Museum of American Art, New York, December 16, 2010–July 16, 2011. Photo: Sheldon C. Collins

rupture and reintegration of its coherent form, exposes that which lies beneath meaning, the reciprocal meeting of an object and its apprehension. That which is released is the difference between it and me.[11]

In this statement, Charlesworth, in contrast with many postmodern theories of pictures, gives *body* to images, figures them dimensionally. What, after all, does it mean to say that one can enter a picture, and, further, that something beneath or beyond meaning is what allows for exchange? I am recalled to the definition of the "Image" advanced by Silvan Tomkins, the radical psychologist whose work rose to prominence during the Cold War and who is known for laying the foundations for what we now call "affect theory." Quite distinct from theories of the image that tether it to technology or media, Tomkins puts forward a concept of the Image rooted in an individual's future purpose. Indeed, Tomkins argues that the Image is in no way hinged to the past via memory, but rather, comprises a "blueprint"—a plan by which a subject lays out a speculative possibility, as well as potential ways to reach it. "In its totality," he writes, "it need not correspond to anything he [the subject] has ever experienced."[12]

My turning to this rarely used idea of the Image, one that, in fact, has no visual corollary at all, is an attempt to imagine a theory of photography that allows photographs to exist as something other than vessels of commemoration.[13] Tomkins's concept of the Image customized, to be sure, outside its original, intended parameters, might allow photographs to be recognizable as objects in the present, while also pointing toward some future, yet unknown. For a series called "Available Light" (2012), some of her last work, Charlesworth produced a dozen photographs, each deftly challenging the distinction between picturing an object as a thing-in-the-world and picturing it as a symbol of or toward something beyond itself. Shooting in her sunlit studio, the artist worked to emphasize and control the natural elements she nonetheless relied on to make each picture.[14] Placing white vellum over the studio's

11. Sarah Charlesworth, *In-Photography* (Buffalo, NY: CEPA Gallery, 1982), 5.

12. Silvan Tomkins, *Shame and Its Sisters: A Silvan Tomkins Reader*, eds. Eve Kosofksy Sedgwick and Adam Frank (Durham, NC: Duke University Press, 1995), 44–45.

13. Such constructions remain overwhelming pervasive, and even inform postmodernist arguments that aimed to fully divorce images from their referents. Roland Barthes's theory of photography, one of the most melancholic, has thrown a particularly long (and seductive, to this writer as well) shadow. To that end, it should be noted that Barthes was deeply influential on Charlesworth (who wrote a book review for *Artforum* when *Camera Lucida* was released in English in 1981).

14. Matthew C. Lange describes this operation nicely. He states that "she worked to control the available light, not simply to let it in." See *Sarah Charlesworth: Stills*, 27.

window magnified, softened, and evened the light source against which various objects were arranged and shot, with the aid of tools including reflectors. In one image, a simple bowl sits squarely in the foreground, centered in the composition. A strange atmosphere of color subtly slices both the amorphous background and the bowl itself, which, filled with water, reflects back a division created solely by directed light. Nothing more than a still life, the bowl somehow assumes mystical status, though in the most uncannily generic sense possible. Here, as in other images in "Available Light," including *Carnival Ball* (2012), the "body" of the image feels as though it expands and contracts— looking at and into the picture, one has the sense that there is infinite space between the object and the wall behind followed by the perception that they occupy a single plane, one blending indistinguishably into the other. And yet, impossibly, looking at these images, a viewer is able to enter them.

Tomkins, in suggesting that an Image can act as a kind of blueprint, means to emphasize that *intention* (whether impulsive or carefully considered) relies, to some degree, on a leap of faith. Returning, once more, to Charlesworth's "Stills," we can perhaps look at them through a different lens than before. "The jumps are all jumps of choice," Charlesworth reminds us, "but the choice may be toward survival—life—or toward death. And the outcomes do not necessarily reflect the intention. But this is all information which exists outside the image."[15] What is in the image—blown up to human scale, hung at eye level—is the opportunity to enter it and to experience, as the artist put it, "a reciprocal meeting of an object and its apprehension." Not falling, that is to say, but flying.

15. Sussler, 23–24.

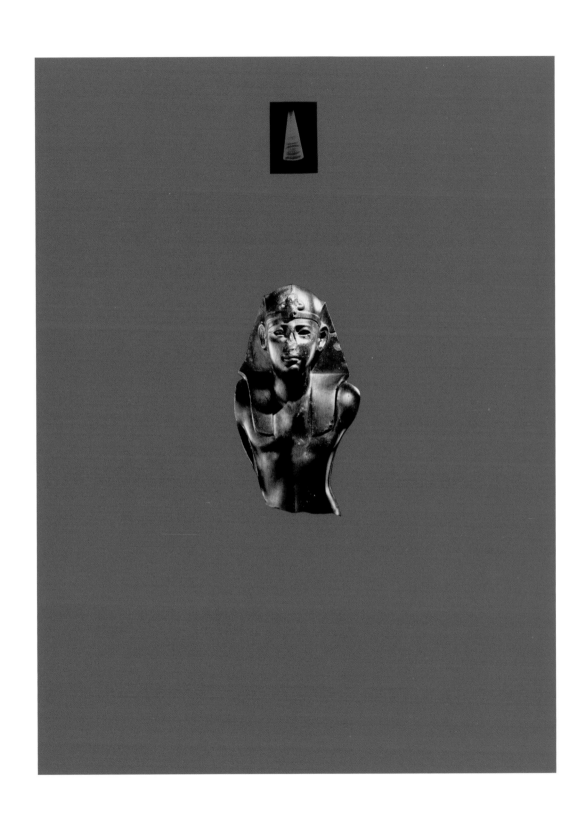

Sphinx, from the "Objects of Desire" series, 1986. Cibachrome print with lacquered wood frame, 42 x 32 in (106.7 x 81.3 cm)

Occupants of Image-World

Margot Norton

> I don't think of myself as a photographer. I've engaged questions
> regarding photography's role in culture...but it is an engagement with
> a problem rather than a medium.
>
> —Sarah Charlesworth, 1989

What is a photograph? What are its limitations and its possibilities? When is it an image and when is it an object? What values does it represent? When does a photograph conflate with the memory of an event or the way that we position ourselves in the world? This trajectory of inquiry and the many questions it incites inform the work of Sarah Charlesworth. In summoning this line of investigation, she opened up fertile and complex ground for generations of artists succeeding her. Invested with rare precision and dedication, she produced an influential body of work and a philosophy on art-making that continue to reverberate and take on shifting significance with time as new technologies emerge and our inexhaustible reservoir of images expands.

In an interview in the 2007 issue of *North Drive Press*, Charlesworth, speaking to the younger artist and photographer Sara VanDerBeek, explains her frustrations with the word "appropriation" as applied to her work with photography.[1] Charlesworth recalls that when she began working, photography was first and foremost about making images and framing the world around us; when she worked with images from newspapers and magazines, she "wasn't appropriating them in the sense of taking them, but rather addressing the language of representation, addressing the conventions by which photography describes and orders the world for us." Her central objection to the word "appropriation," which she would have preferred to replace with "quotational," is that "it eclipses so much of the subtlety and complexity of the way in which that referencing or recontextualizing functions." She goes on to express that VanDerBeek's own work is not "copying or stealing, but rather doing something way more complex and challenging in terms of understanding yourself as an occupant of a world of images."[2]

While often employed as a catchall term to describe techniques used by artists of Charlesworth's generation who came to prominence in the 1980s, the word "appropriation" does not figure in quite the same way when used in discussions of contemporary artists. Artists today draw liberally from found sources in every medium—a practice that is so predominant that it is no longer emphasized in critical discourse. Perhaps this turn of focus in the practice's acceptance might be one criterion by which Charlesworth's influence can be measured. In deconstructing and recontextualizing found images, Charlesworth pioneered an approach to mining the language of photography that directly confronted the ubiquity of images and its profound imprint on our everyday lives. As she told David Clarkson in an interview in *Parachute*

1. *North Drive Press* was an annual art publication founded by New York–based artists Matt Keegan and Lizzie Lee in 2003 that produced five issues between 2004 and 2010. Collaborators included Susan Barber, Sara Greenberger Rafferty, and Sadie Laska. Rafferty and Keegan, Coeditors of *North Drive Press* issue 4, invited Charlesworth to do an interview with VanDerBeek for their issue.
2. "Sarah Chalesworth and Sara VanDerBeek: An Interview," *North Drive Press* 4 (2007): 7–8.

in 1987, "In one sense, we live in a regular three-dimensional physical world, and in another sense, we inhabit an entirely different image-world. I think that all my work situates itself within a landscape of images. I see photography as the dominant language of contemporary culture…. This is a situation without historical precedent, and that's the reason why, as a contemporary artist, I feel it's a primary issue."[3]

A student of first-generation Conceptual artist Douglas Huebler, Charlesworth came from a background rooted in the idea- and language-based practice of Conceptualism. In the 1970s, she and the artist Joseph Kosuth, with whom she was in a romantic as well as a professional relationship, collaborated on many projects, including coediting the short-lived though influential art theory publication *The Fox*, which produced three issues from 1975 to '76. With the creation of her first mature series from that time, "Modern History" (1977–79), Charlesworth sought to engage with the act of "unwriting"[4]—laying bare the syntax of photography, which is, at its essence, a form of writing with light. For this body of work, Charlesworth photographed the front pages of different newspapers and redacted the texts, erasing everything except for the mastheads and images on the pages. By repeating this manipulation of a single publication's front page over the course of a month (*Herald Tribune, September, 1977* [1977]) or of the varying representations of a single event on a specific day found in many different publications (*April 21, 1978* [1978] and *Arc of Total Eclipse, February 26, 1979* [1979]), these works revealed a hierarchy of power as evidenced by the inherent underpinnings of editorial decisions with respect to size, cropping, and placement. With this series, Charlesworth uniquely straddled the academic rigor of Conceptual art and the image-play of the later-identified "Pictures Generation."[5] While she confronted the growing concern with representation in an age and society marked by burgeoning media saturation—as many of her peers were also doing (Louise Lawler, Sherrie Levine, Richard Prince, Cindy Sherman, and Laurie Simmons among them)—she was also utilizing a highly structured, systematic framework that echoed and recapitulated Conceptual practice. An important aspect of "Modern History" is that the size of each photograph Charlesworth produced precisely replicated the size of the front page of the particular newspaper that she altered. In fact, the carefully determined sizes of Charlesworth's photographs and their inherent relationships to the viewer's body are fundamental characteristics of her work that are not often discussed. Her process with each series, each image, and each installation that she produced was inextricably tied to the concept behind the work itself. No aesthetic decision—size, cropping, framing, color, photographic technique, etc.—was arbitrary.

In a recent panel accompanying the exhibition "Sarah Charlesworth: Stills" at the Art Institute of Chicago, Simmons, a fellow Pictures Generation artist and close friend of Charlesworth's, noted how astonishing the inflated scale of the images in her 1980 "Stills" series was, and how unusual it was to see photographs of that size back when they were created.[6] With "Stills," Charlesworth was breaking away from the tradition of the precious eight-by-ten black-and-white silver gelatin print in fine art photography that was the predominant convention at the time. For this poignant series, she rephotographed clippings from press images that depict people falling or jumping off of buildings, suspended in air and in time. The title of each image gives the name of the person and the location where the photograph was taken (if known), leaving the rest

3. David Clarkson, "Sarah Charlesworth: An Interview," *Parachute*, December 1987, 14; reprinted in this volume, 107.

4. Sarah Charlesworth, "UNWRITING: Notes on Modern History," in *Modern History (Second Reading)* (Edinburgh: New 57 Gallery, 1979).

5. "Pictures Generation" describes a loosely knit group of artists working in New York in the 1980s that examined the visual language of mass media and the imprint of images on everyday life. The group was named for the important exhibition "Pictures," organized by Douglas Crimp at Artist's Space in 1977, which included artists Troy Brantuch, Jack Goldstein, Sherrie Levine, Robert Longo, and Philip Smith. The Pictures Generation later came to encompass a larger group of artists engaging with the problems of representation such as Charlesworth, Barbara Kruger, Louise Lawler, Richard Prince, Cindy Sherman, and Laurie Simmons, among others. A major exhibition titled "Pictures Generation" was organized by Douglas Eklund in 2009 at the Metropolitan Museum of Art in New York, with a catalogue distributed by Yale University Press.

6. "Panel Discussion: Sarah Charlesworth" with artists Liz Deschenes, Laurie Simmons, and Sara VanDerBeek, and activist Kate Linker. This panel was held in conjunction with the exhibition "Sarah Charlesworth: Stills" at the Art Institute of Chicago on September 17, 2014.

of the narrative unspecified. With this omission of an identifying context, the viewer is left to ponder the rest of the story and to reflect on whatever preconceived notions he or she may harbor, effectively exposing the ambiguity of the photographic reproduction. Charlesworth decided to print these images slightly larger than human scale, at six-feet-six-inches tall, and on a lighter and lower-quality silver gelatin paper that was typically used for printing commercial murals. She was, in fact, one of the first artists to embrace printing at this scale and employ these cheaper materials. Since the photographs themselves are printed on an outsize scale much larger than their resolution, the resulting images border on abstraction, with the lines and dots that make up the texture of the image creating geometric patterns on the surface of the picture. These "photo-objects," as Jerry Saltz described them in a 1988 review,[7] are as rigorous as they are emotional. Approaching the personally resonant and the aesthetically beautiful with a critical and purposeful methodology was a hallmark of Charlesworth's practice and would remain a constant throughout the more than twenty distinct series that she produced.

Beginning with "Modern History" and "Stills" and continuing over the course of her career, Charlesworth amassed a vast collection of images—clippings from newspapers, fashion magazines, pornography, and textbooks, among many other sources—that were organized into folders by subject or theme. Select images relating to a particular concept that she was exploring were then put aside or pinned to the studio wall for further consideration.[8] She employed a painstaking methodology to create her series "Objects of Desire" (1983–88), which on the surface, seems effortlessly contemporary today, given the advent of Photoshop. In fact, many of the specific processes she utilized would now be regarded as labor-intensive and antiquated. Literally cutting and pasting, she would incise the "objects" with an X-acto knife, cropping out all extraneous information, and paste them onto a monochrome graphic arts board commonly used by the magazine designers of that era specifically for page layouts. The arrangement was then photographed at a "repro house" (a facility that mostly catered to the magazine and print industries) using large-format, color transparency film. (This was a technique used to create color separations and plates for printing presses before the advent of the digital scanner.) After this routine reproduction process, Charlesworth would then fluidly segue into photographic technique, bringing the transparencies to a traditional photo lab to be printed on thirty-by-forty-inch Cibachrome paper,[9] mounted, coated with a UV-resistant high-gloss laminate, and framed with lacquered wood selected to match the color of the print.

The resulting works, with their highly saturated background colors and shiny surfaces, are luscious and tactile. It is impossible to view one of these works without becoming cognizant of your own reflection and the reflection of the surrounding room. Not only do the objects depicted elicit desire—both for the objects themselves and for something more personal and diffuse—but the conventions by which they are presented also seduce. The images seem immediately familiar, yet on further inspection they are unsettling. With all contextual information removed, we question how well we might actually know the images we readily consume in our quotidian lives. For example, one of the earliest works from this series, *Red Mask* (1983), presents a delicate, white-painted face with red lips that seems to reference a Japanese geisha, but is instead the face of actor Bandō Tamasaburō V, who worked in the *onnagata* Kabuki theater

7. Jerry Saltz, "The Implacable Distance: Sarah Charlesworth's Unidentified Woman, Hotel Corona, Madrid (1979–80)," *Arts Magazine*, March 1988, 24.
8. Taken from a conversation with Matthew C. Lange, Charlesworth's studio assistant, on January 19, 2015.
9. Kate Linker notes in her essay "Artifacts of Artifice" that the length of one of these photographs approximates the span of a human arm. See Kate Linker, "Artifacts of Artifice," *Art in America*, July 1998, 78; reprinted in this volume, 18–27.

tradition (where men portray women).[10] Similarly, *Sphinx* (1986), which depicts an Egyptian figure that is certainly not a sphinx, persists in conjuring for us, through its inaccurate title, a vivid amalgam, evinced from our repertoire of visual vocabulary. "Objects of Desire" suggests how images might be pre-coded in our consciousness, ultimately revealing their intrinsic influence to predetermine individual attitudes toward material desire, sexuality, and power.

In 1992, Charlesworth transitioned from working with preexisting images to photographing images herself. Even while behind the camera and generating her own photographs, her trenchant investigations and dissections of visual codes continued, along with her fastidious arrangement of objects. For her series "Doubleworld" (1995), Charlesworth explored fetishistic approaches to vision in art, especially as they played out in the mid-nineteenth century, during photography's rise as a mediator of representation.[11] She arranged tableaux in her studio using nineteenth-century antiques, cameras, and optical instruments, as well as fruits, flowers, and skulls—the trappings of the Dutch still life conventionally used to represent abundance and decay. One of her photographs from this series, titled *Doubleworld* (1995), presents two nineteenth-century stereoscopic viewing devices, each holding a stereo-photograph depicting two women standing side by side. This continuous doubling of images underscores the duplicitous role of the photograph as an alternate, optical universe and stand-in for the physical world. *Allegory of the Arts* (1995), another work from this series, is arranged to replicate a specific anonymous artwork from the 1850s.[12] In these works, Charlesworth carefully constructs the "past" in the present, revealing how the phenomenon of vision is itself ingrained historically. It is interesting to note how the act of "doubling" presents itself throughout Charlesworth's oeuvre: certain objects and images from earlier series, such as the Buddha or Shiva from "Objects of Desire," recur in later works and series such as *Figure Drawings* (1988/2008) and "0+1" (2000). The candle that is featured in *Candle* (2002), from the series "Neverland" (2002), and the telescope in *Untitled (Voyeur)* (1995), from the series "Doubleworld," both appear again in the series "Available Light" (2012).

The working title for her latest and last series, "Available Light," was "Constant," alluding to the resolute process by which a photograph is made[13]—an exactitude of technique that, of course, was also an unyielding concern of Charlesworth's. This series summarized many of the artist's techniques for exploring the photographic "problem." Creating still lifes composed of objects and/or images of objects in her studio, she relied on the available daylight from her studio window as a source for illumination. Two works from this series, *Studio Wall* (2012) and *Magical Room* (2012), turn her lens on the wall of her workspace to reveal her process: clippings of found images are pinned to the studio wall; printed photographs from the series are also on view for consideration, as are three-dimensional objects from this series' repertoire; and tools for cutting and pasting are revealed on her worktable. Charlesworth referred to *Magical Room* as the "key" to the series, laying bare her artistic process itself.[14]

In addition to her prodigious career as an artist, Charlesworth was a writer and an educator. She held teaching positions at institutions including New York University, the Rhode Island School of Design, the School of Visual Arts, and, most recently, Princeton University. She was tremendously generous in

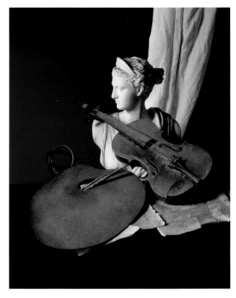

Allegory of the Arts, from the "Doubleworld" series, 1995. Cibachrome print with mahogany frame, 51 x 41 in (129.5 x 104.1 cm)

10. David Deitcher, "Questioning Authority," *Afterimage* (Summer 1983): 15.
11. Charlesworth referred to the following titles as resources for her series "Doubleworld": Jonathan Crary, *Techniques of the Observer: On Vision and Modernity in the Nineteenth Century* (Cambridge, MA: MIT Press, 1990); Barbara Stafford, *Artful Science: Enlightenment, Entertainment, and the Eclipse of Visual Education* (Cambridge, MA: MIT Press, 1994); and Norbert Schneider, *The Art of the Still Life: Still Life Painting in the Early Modern Period* (Cologne: Taschen, 1990).
12. Susan Fisher Sterling, "In-Photography: The Art of Sarah Charlesworth," in *Sarah Charlesworth: A Retrospective* (Santa Fe: SITE Santa Fe, 1997), 86.
13. "Matthew S. Witkovsky and Matthew C. Lange in Conversation," in *Sarah Charlesworth: Stills*, ed. Matthew S. Witkovsky (Chicago and New Haven: Art Institute of Chicago and Yale University Press, 2014), 28.
14. Taken from a conversation with Matthew C. Lange.

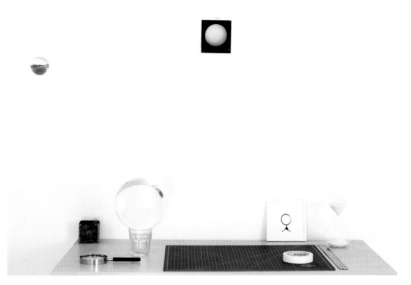

Magical Room, from the "Available Light" series, 2012. Fuji Crystal Archive print with lacquered wood frame, 41 x 32 in (104.1 x 81.3 cm)

her relationships with younger artists, and many of them look up to her work and her ethics as sources of major inspiration. Her impact is apparent in the work of artists with whom she had formed relationships, including her former student and studio assistant Matthew C. Lange, and artists Talia Chetrit, Liz Deschenes, Sara Greenberger Rafferty, and Sara VanDerBeek. Lange noted how Charlesworth "exemplified an ability to remain critical toward your own work" and how that approach had a "huge influence" on his practice.[15] Rafferty described three exemplary qualities that Charlesworth's practice embodied: her marriage of the formal with the conceptual and "real pleasure and investment in making objects"; her status as a "model of an artist who is discursive—teaches and makes work, and is involved with publications"; and her "real commitment to ethics in everything that she did."[16] Deschenes, whose own rigorous constructions expand the material potential of the photographic medium, emphatically stated at the Art Institute of Chicago panel in 2014, "If Sarah and her generation hadn't made the marks that they made, it would be impossible for me to have the career and practice that I've managed to have."[17]

The works of other contemporary artists, some of whom may not be aware of Charlesworth's direct influence, are also indebted to the particular formal and conceptual tools that she established over the course of her career. Her impact can be perceived in the work of many artists working today who, like Charlesworth, collect, assemble, dissect, and manipulate public imagery, as with Daniel Gordon's photographs of three-dimensional assemblages of pictures gathered from Google Image searches or Matt Lipps's recontextualized and theatrically lit cutouts from coffee-table books and magazines. Elad Lassry, who has referred to his practice as a "post-picture-generation approach,"[18] has similarly culled images from vintage magazines and film archives, removing them from their original contexts. As Lassry has said, "I'm

15. Ibid.
16. Taken from a conversation with Sara Greenberger Rafferty on January 24, 2015.
17. "Panel Discussion: Sarah Charlesworth" at the Art Institute of Chicago.
18. Elad Lassry, as quoted in Christopher Bollen, "Elad Lassry," *Interview*, November 2008, 42.

fascinated by the collapse of histories and the confusion that results when there is something just slightly wrong in a photograph."[19] His works, which are all scaled to roughly magazine-size at fourteen and a half by eleven and a half inches, are also all fitted with painted frames that explore the tension between photograph as image and as object, as Charlesworth had pioneered with her series "In-Photography" (1981–82) and "Objects of Desire." Many other artists have given particular attention to the expressive potential of framing devices, as evident in the overlapping or smashed-together frames of Brendan Fowler's work; Chris Wiley's fabric-wrapped, stuccoed, or carpeted supports; and the incised and irregularly shaped frames that play off the digitally manipulated images in the work of Kate Steciw. Some have pushed the boundaries of the photographic support even further: Letha Wilson has affixed her C-prints to raw cement, plywood, and drywall; Josh Kolbo has created double-sided, monumental C-prints, some as long as eighteen feet, which hang loosely off the wall; and Marlo Pascual has often folded and studded her Plexiglas and sintra-mounted frames with objects ranging from fluorescent lights to potted plants.

Of course, artists today inherit a much broader set of concerns than Charlesworth did when she began working with photography. As digital images are more widely disseminated and at an increasingly rapid pace through text, email, and social media, photography has become so ubiquitous and disposable that it is virtually invisible. We have come far from the "multiple copies" that Walter Benjamin spoke of in his renowned essay "The Work of Art in the Age of its Technological Reproducibility" (1936).[20] Referencing Benjamin, Charlesworth herself delivered the following forecast in 1987: "We are not even talking about multiple copies. We are talking about global electronic computerized satellite-dished transmission of images, reaching millions of people!"[21] The impact of the digital age on contemporary photography and the wide range of possibilities for manipulating photographic conventions have been explored in numerous recent group exhibitions, many of which include the artists mentioned in the previous paragraph.[22] A number of these artists, like Charlesworth, have primarily studio-based practices that involve setting up arrangements and still lifes of objects and images for the camera—as in the work of Sara VanDerBeek and Annette Kelm—or experimenting with photographic processes, and even, at times, dispensing with the camera altogether—as in the work of Walead Beshty, Eileen Quinlan, and Mariah Robertson.

In their 2007 interview, Charlesworth gave this response to VanDerBeek regarding the difference between the artistic community of her generation and that of today: "I think that part of the shift that's taken place in the last twenty years is that there is a broader, more horizontal field, more cultural locations from which one can speak or be recognized."[23] Perhaps this "shift" that Charlesworth describes is due, in part, to the aforementioned technological changes. But it is also indebted to the legacy set forth by Charlesworth and her generation of fellow artists that trailblazed a broadened landscape for art-making. No longer do we consider photography to be a singular, fixed discipline, as was the popular perception when Charlesworth began working in the 1970s. Instead, it is a plural term, encompassing rich territory for artists to probe, provoke, expand, and reinterpret. In fact, Charlesworth, months before her sudden passing in 2013, developed a syllabus for a seminar course at Princeton entitled "Photographies," her plural term alluding to the multiplicity of

19. Ibid.
20. See Walter Benjamin, "The Work of Art in the Age of its Technological Reproducibility" (1936), in *Selected Writings: Volume 3: 1935-1938*, eds. Michael Jennings et al. (Cambridge, MA: Harvard University Press, 2002).
21. David Clarkson, "Sarah Charlesworth: An Interview," *Parachute* (December 1987): 14; reprinted in this volume, 108.
22. See the following exhibitions: "Photo Poetics," the Solomon R. Guggenheim Museum, New York (2015–16); "What Is a Photograph?" the International Center of Photography, New York (2014); "Fixed Variable," Hauser & Wirth, New York (2014); "The Material Image," Marianne Boesky Gallery, New York (2014); "One Step Beyond: Focus on New Photography," Galerie Christophe Gaillard, Paris (2014); "Lens Drawing," Marian Goodman Gallery, New York (2013); "Photography Is," Higher Pictures, New York (2012); "The Anxiety of Photography," Aspen Art Museum, Colorado (2011); "Image Transfer: Pictures in a Remix Culture," Henry Art Gallery, Seattle (2010) in partnership with Independent Curators International (ICI); and "Phot(o)bjects," Presentation House Gallery, Vancouver (2009).
23. "Sarah Chalesworth and Sara VanDerBeek: An Interview," *North Drive Press* 4 (2007): 9.

approaches to the medium that have emerged over the course of its history. Today, it remains as meaningful for artists to address the constructs of their own time as it was in 1976 when Charlesworth wrote the following incisive mantra in *The Fox*: "Twentieth century battles cannot be fought, I suspect, according to Victorian battle plans."[24]

24. Sarah Charlesworth, "For Artists Meeting," *The Fox* 3 (1976): 41.

STILLS

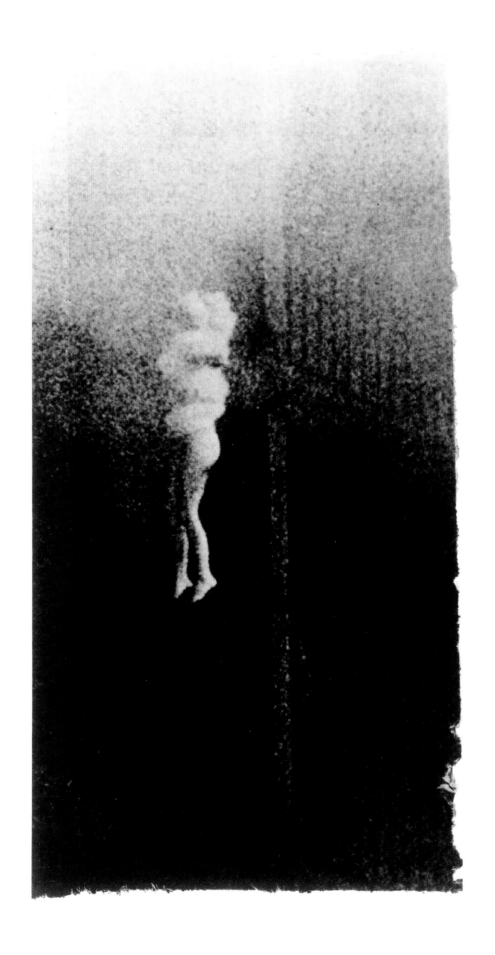

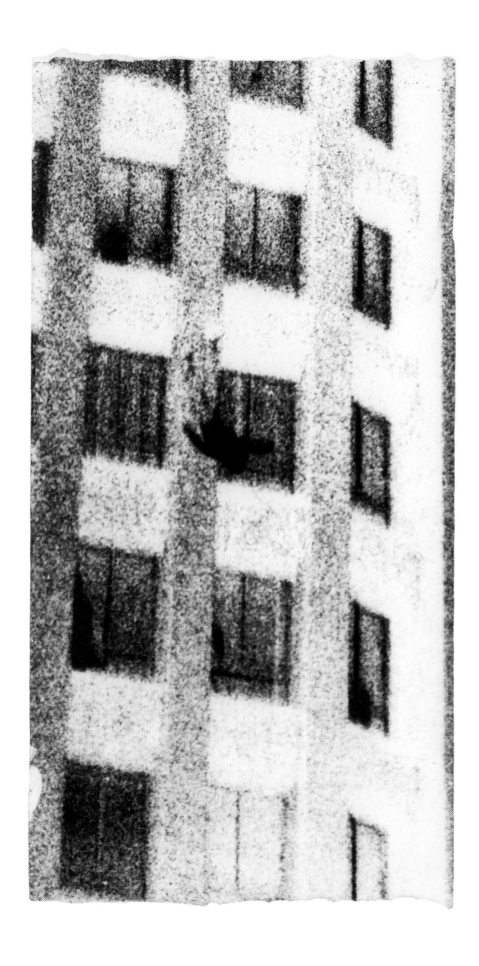

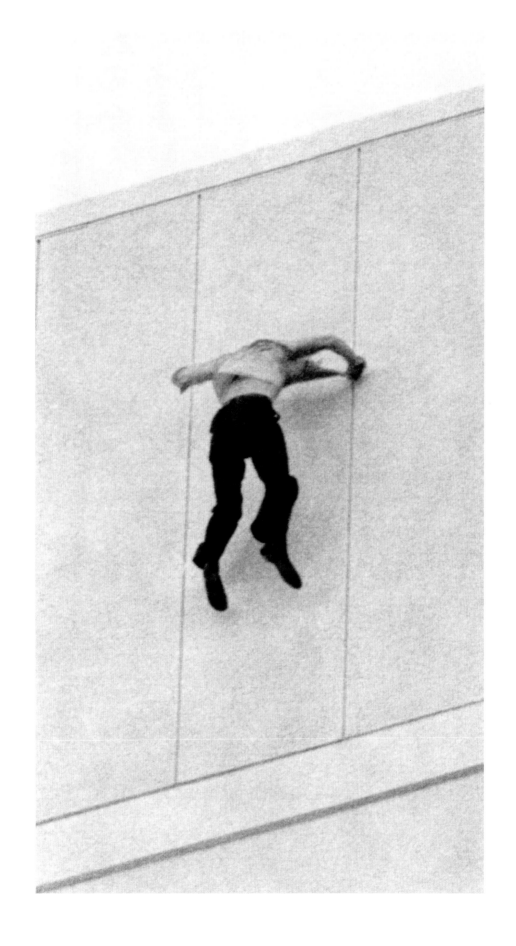

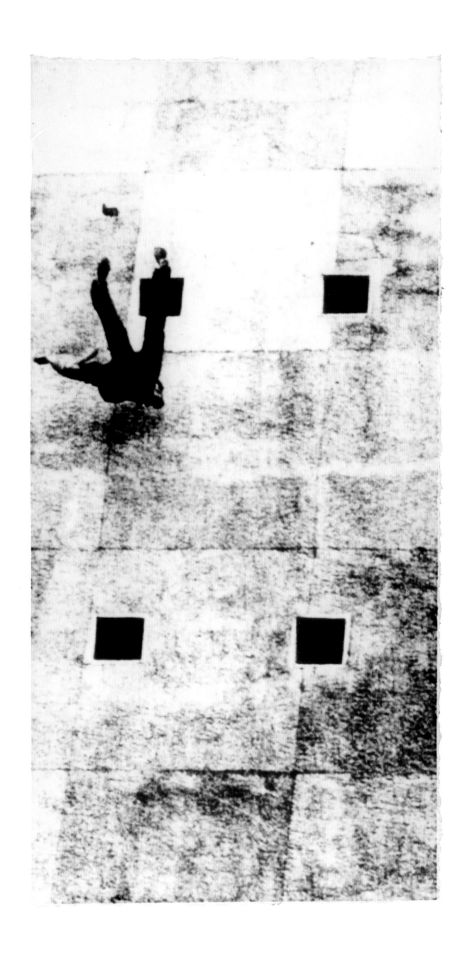

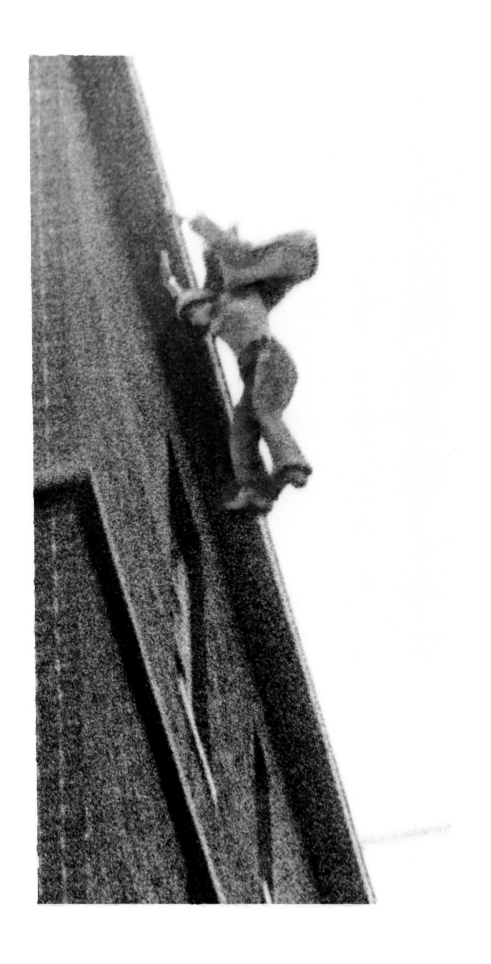

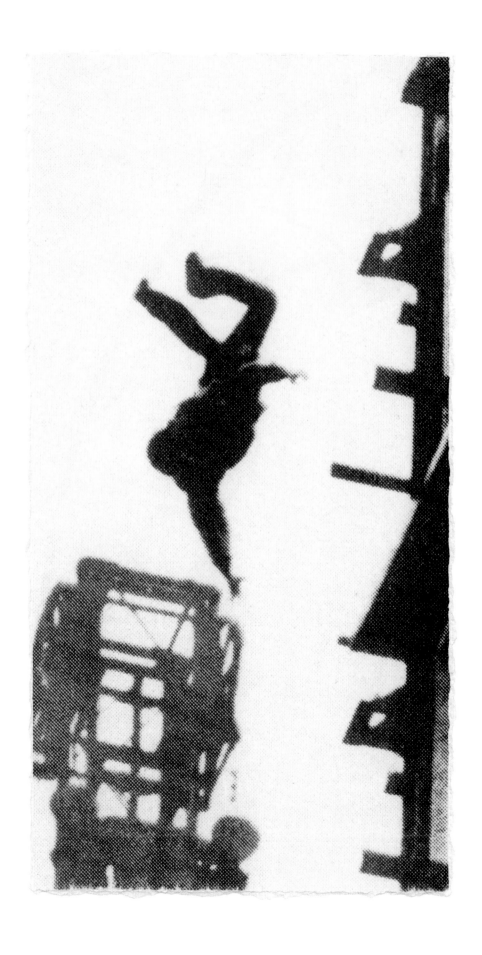

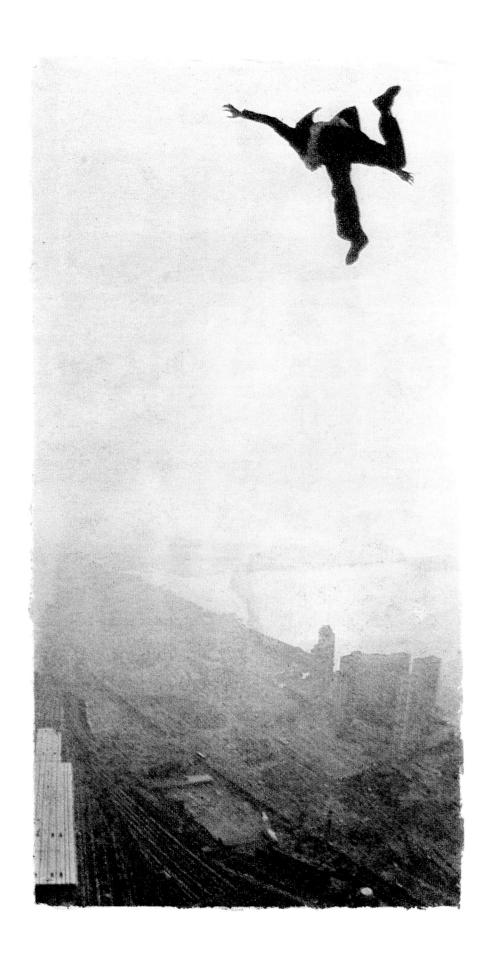

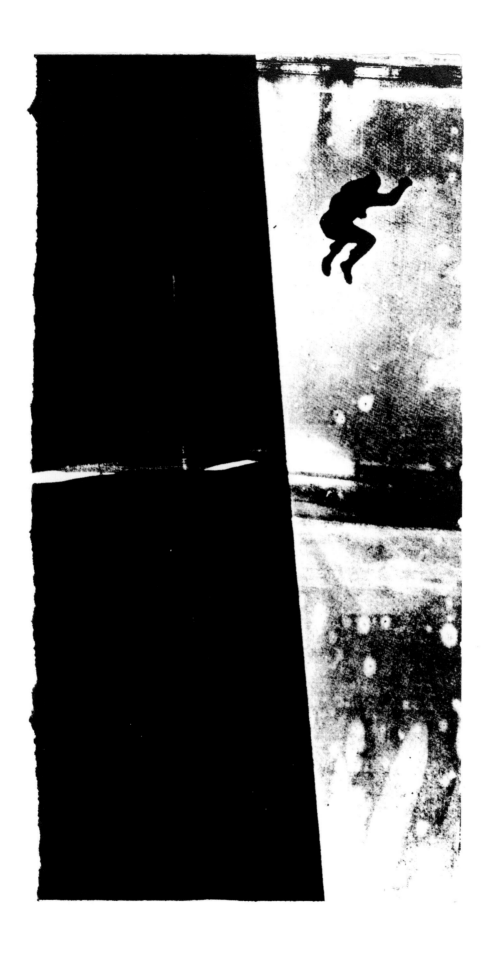

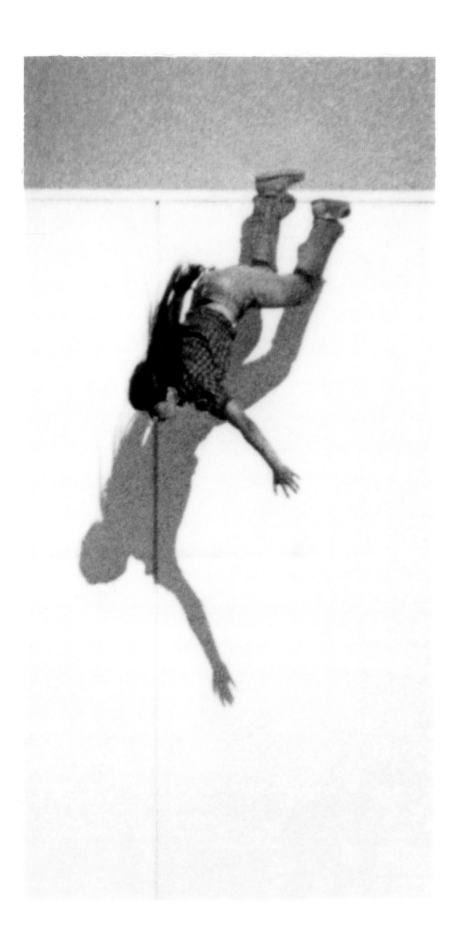

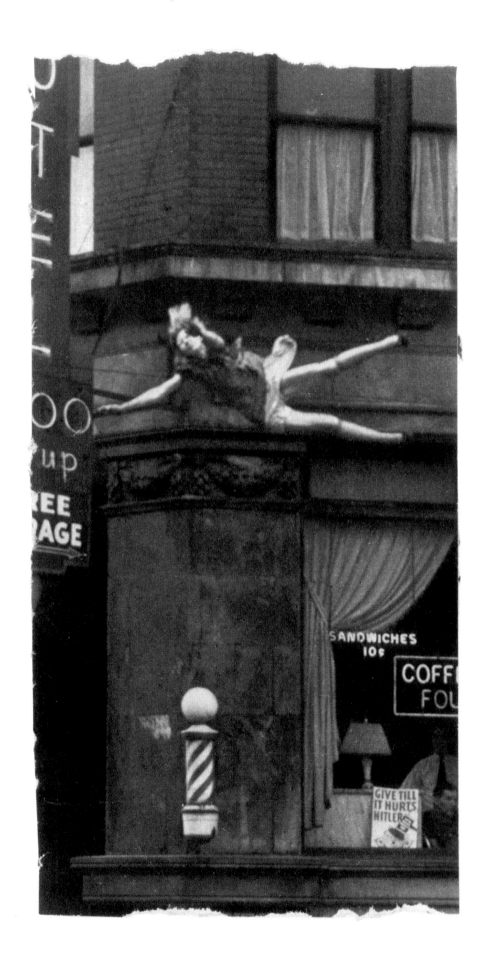

54

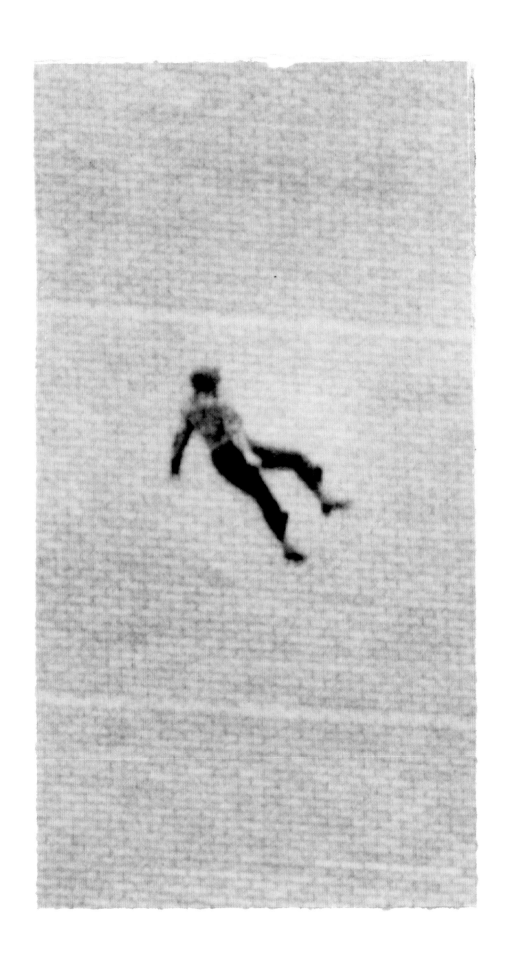

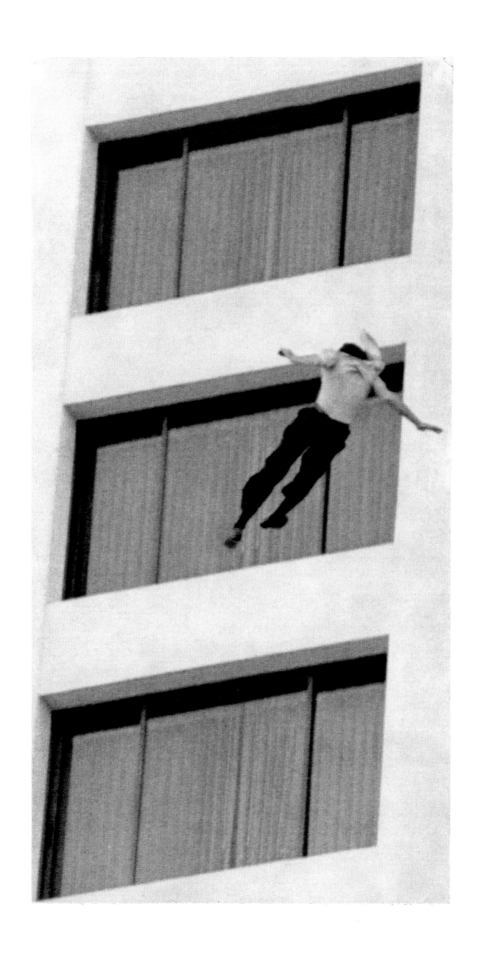

OBJECTS OF DESIRE

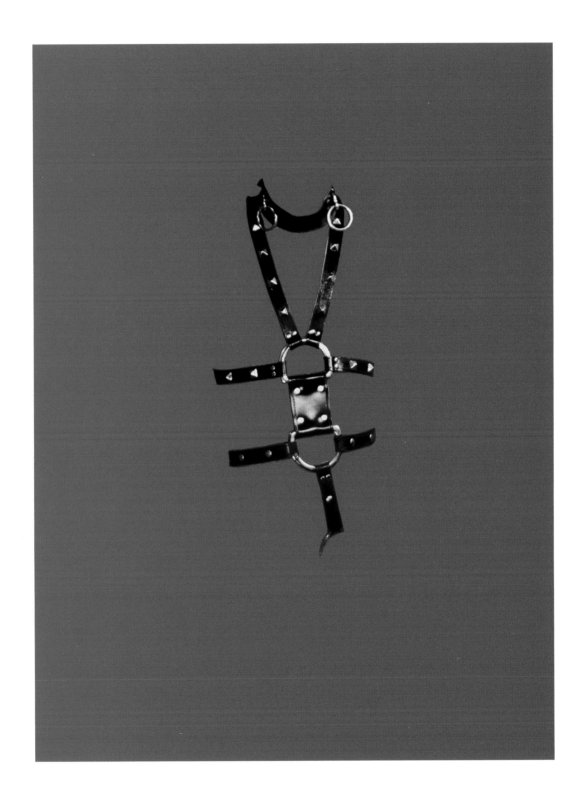

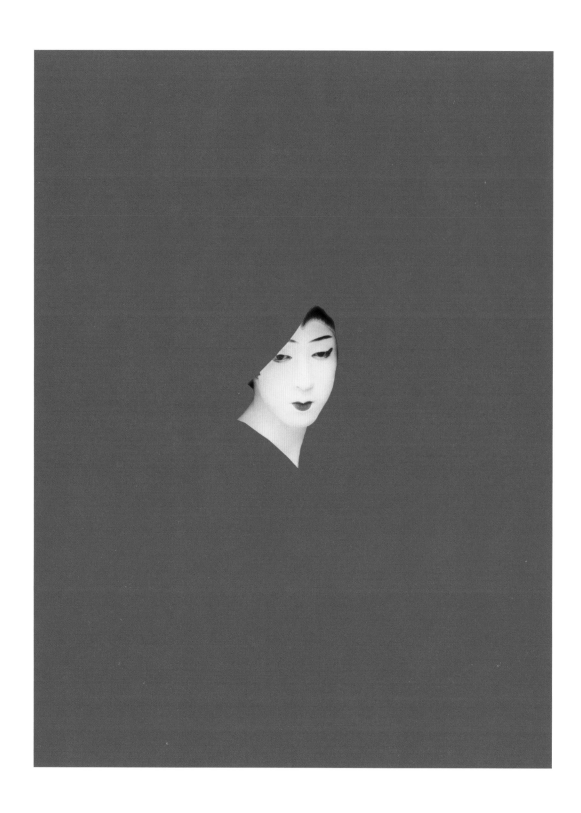

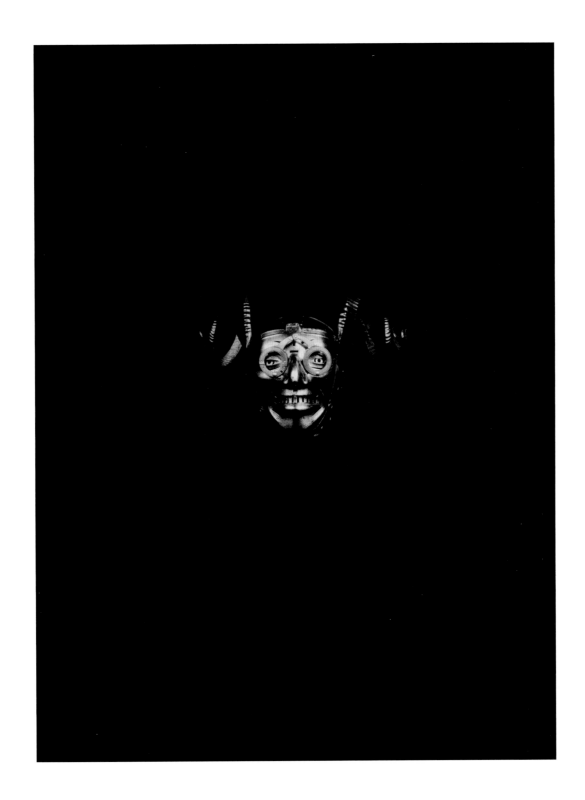

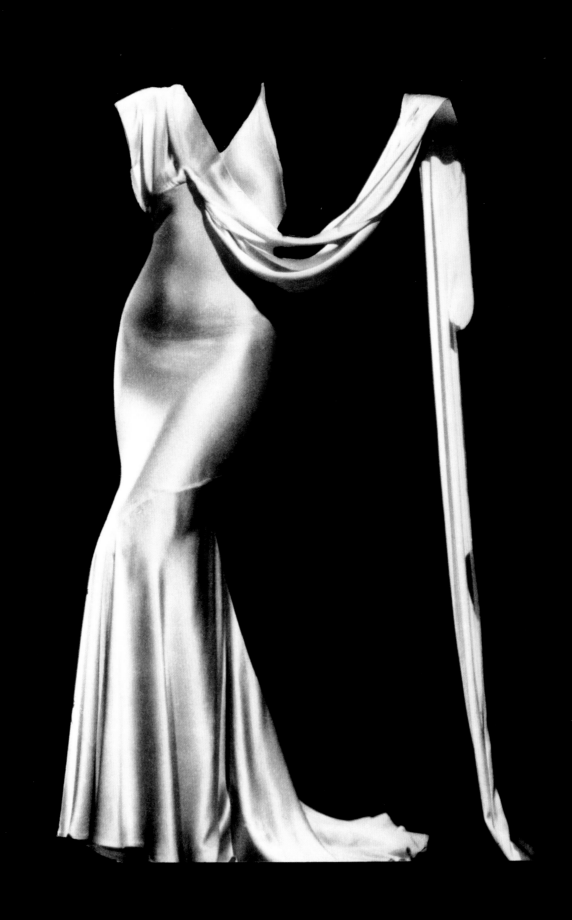

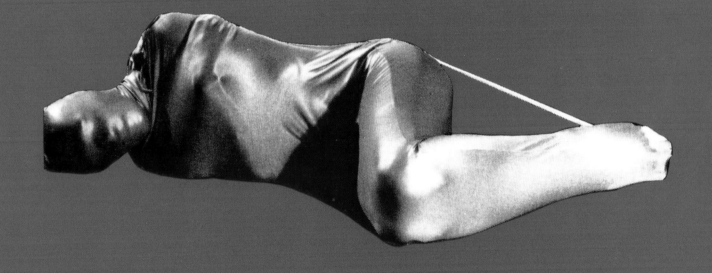

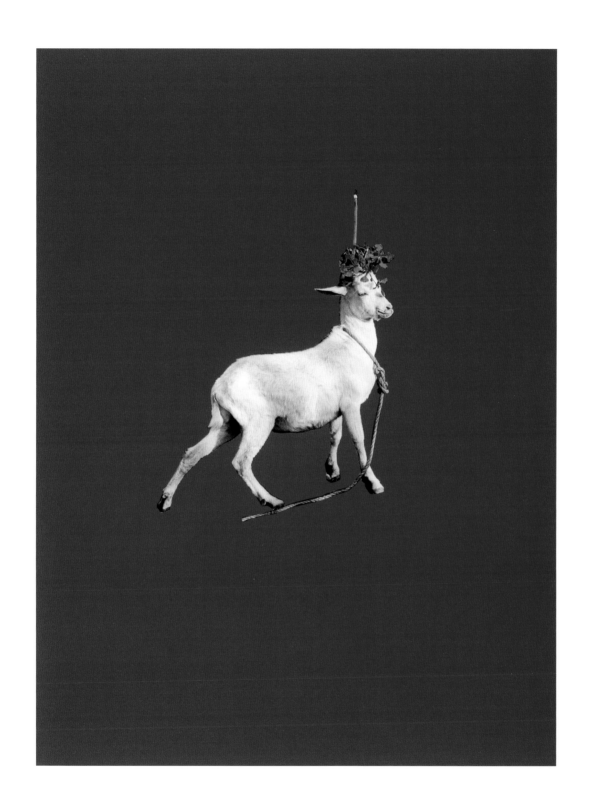

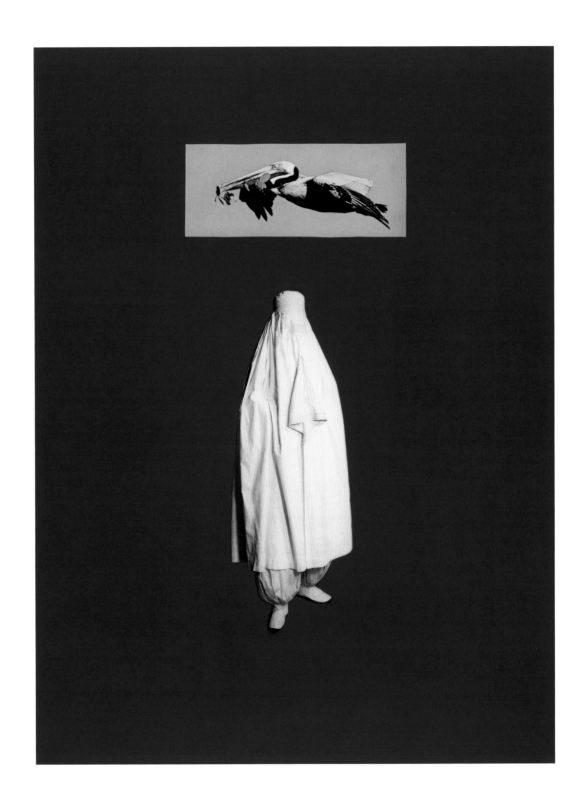

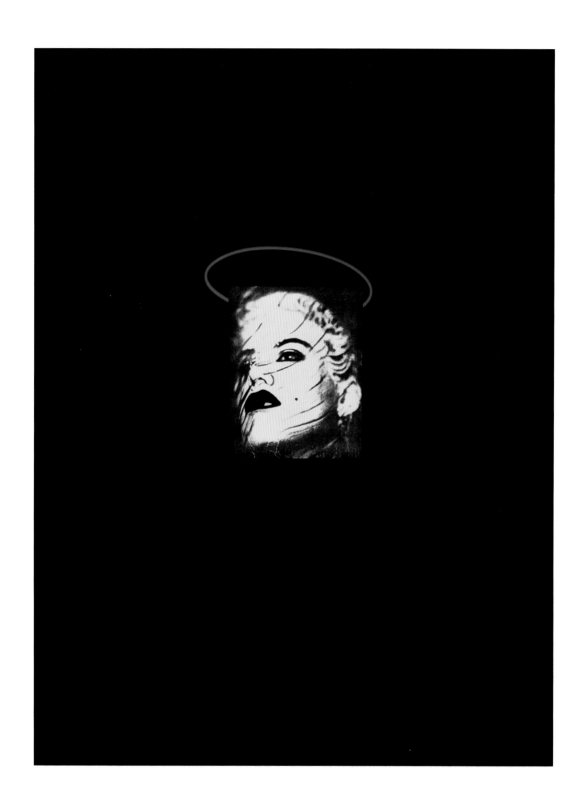

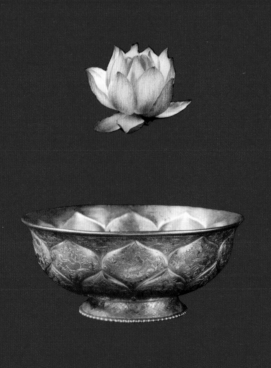

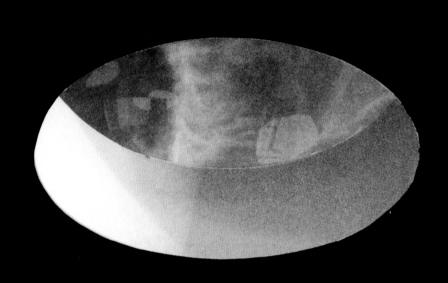

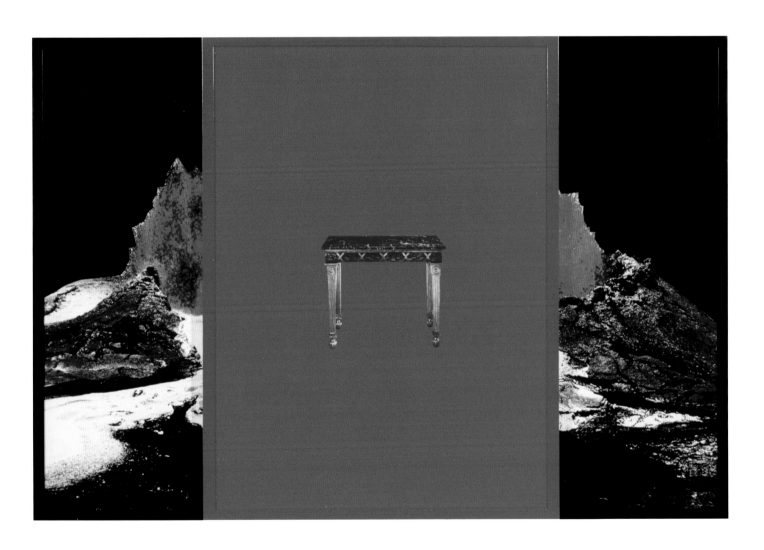

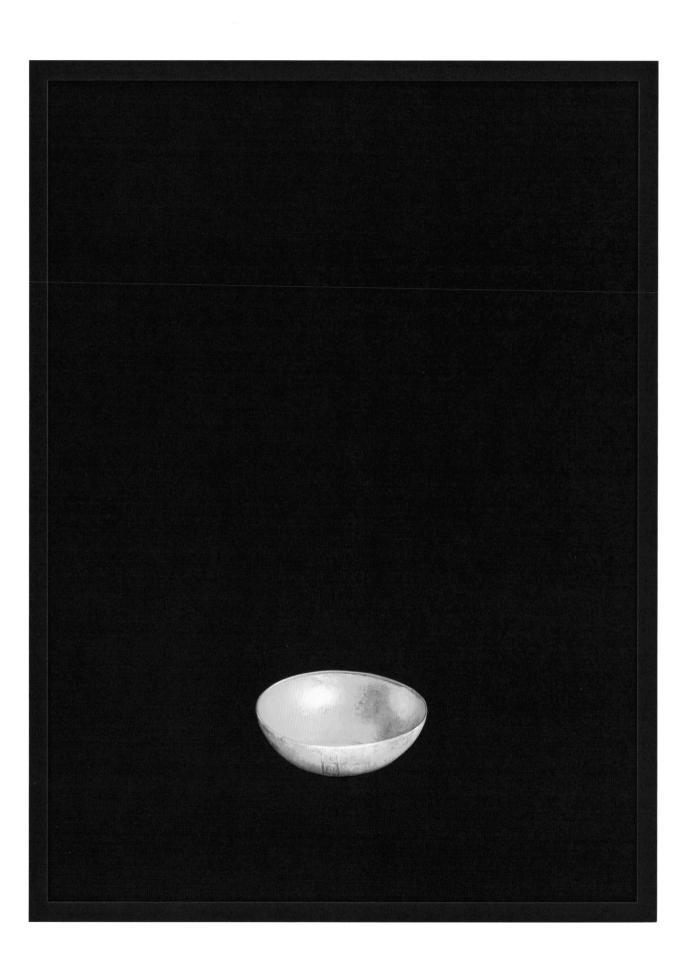

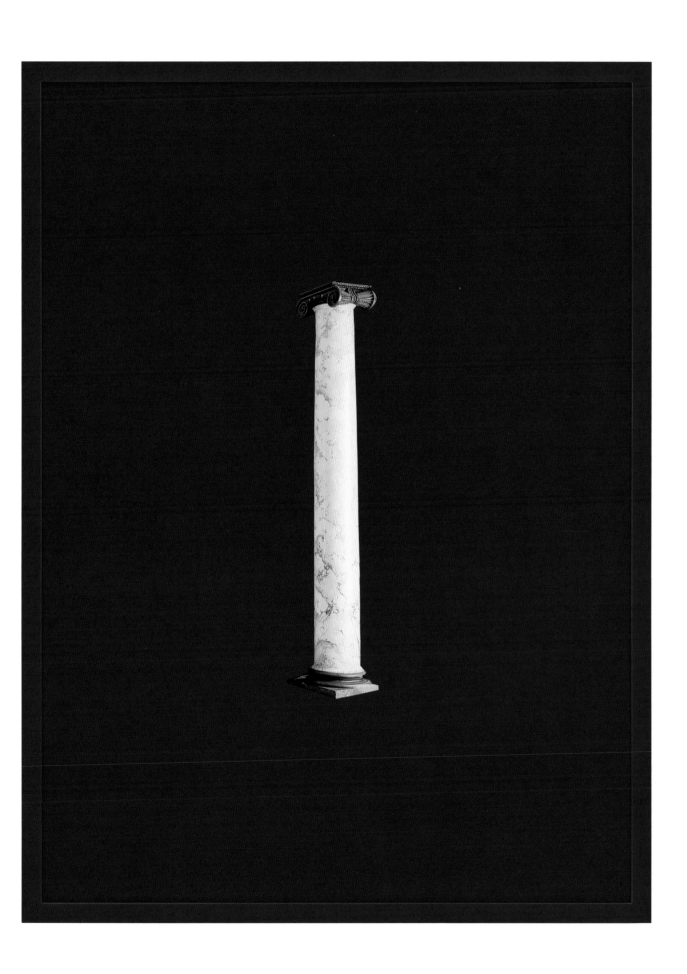

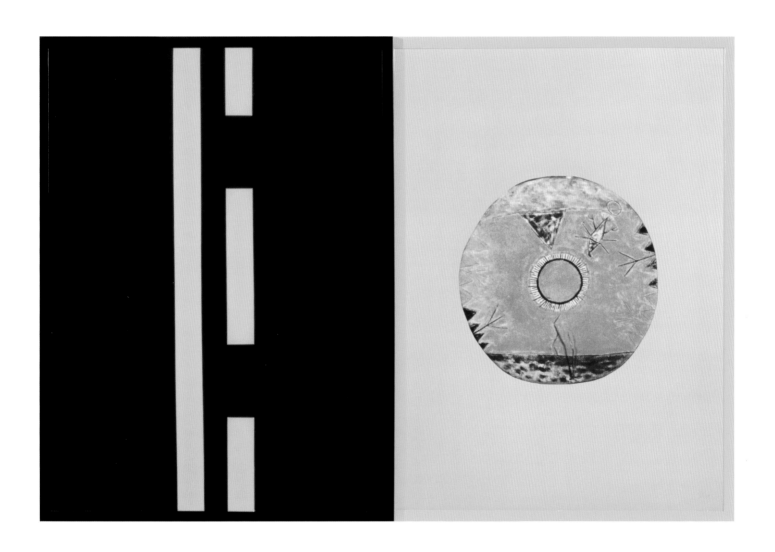

RENAISSANCE PAINTINGS

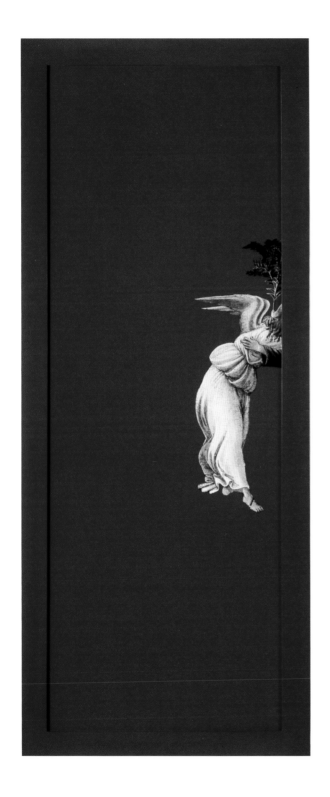

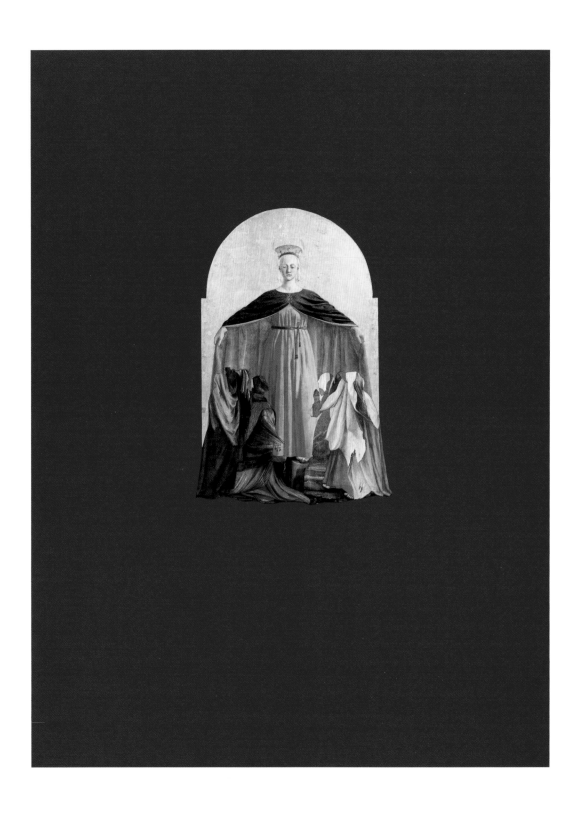

DOUBLEWORLD

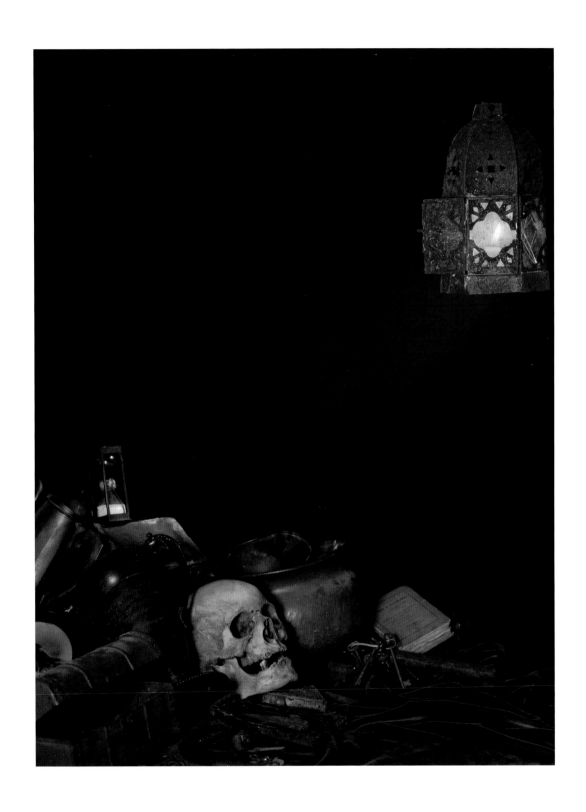

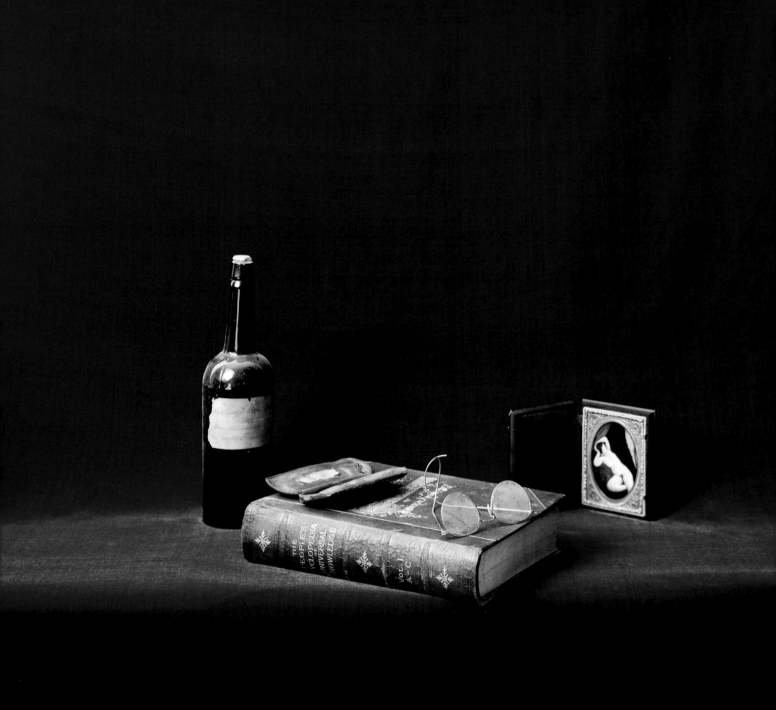

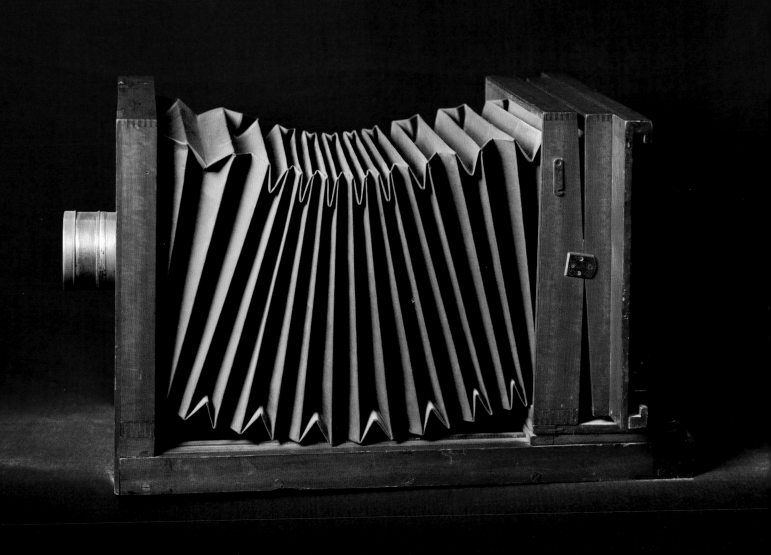

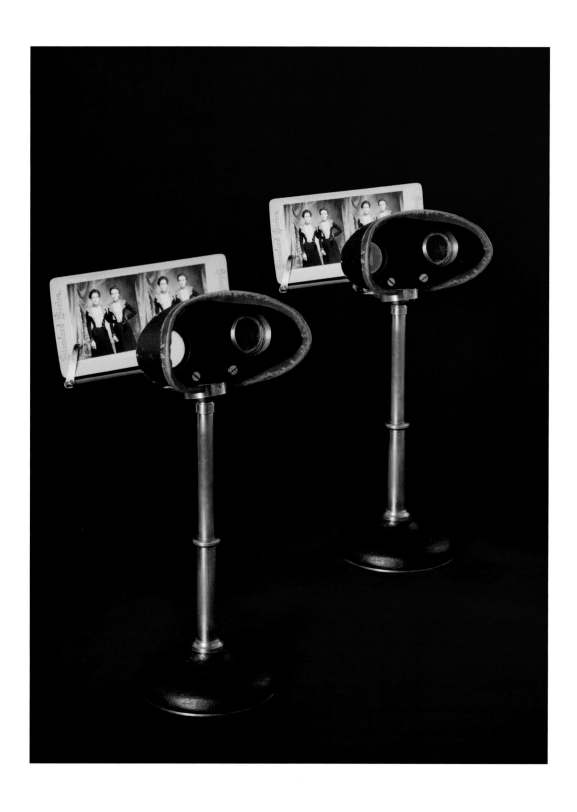

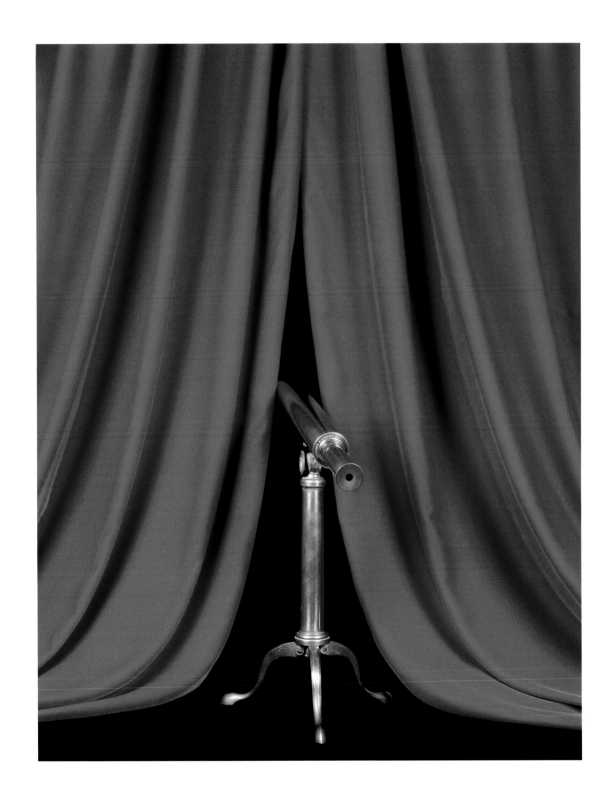

Post-Modernism and Photography

Panel paper by Sarah Charlesworth*

Society for Photographic Education
March 1983, Philadelphia
Panelists: Sarah Charlesworth, Douglas Crimp, Richard Prince, Laurie Simmons
Moderator: Andy Grundberg

When I was first invited to participate on this panel, while I felt qualified to discuss theoretical issues related to photography and its historical development, its aesthetic and commercial conventions, its relationship to Art, and most importantly, its complete integration into the conceptual apparatus of modern self- and world-identity, I had not considered the concept of Postmodernism as it relates specifically to photography or vice versa. I didn't even know exactly what Postmodernism was supposed to be, other than a convenient catchall term used to refer both affirmatively as well as pejoratively to the entire random, erratic spectrum, the eclectic free-for-all, that has marked artistic practice since the early 1970s, following the generally agreed-upon demise of Modernism. (And now upon a little further research, I found out that I am one [of these Postmodern artists].) Modernism, by comparison, seemed to exert (through tradition) a kind of ideological coherence, a historical trajectory choreographed by artists and art historians alike, responding to the progressive and self-reflexive dialectic of movement and counter-movement. Modernism, it seemed, was not so much destroyed as completed. A tradition premised simultaneously on the commitment to autonomy and radical self-exploration had culminated quite logically in the self-discovery of Modernism, through Minimalism, Pop, and, finally, Conceptual art. [Modernism discovered] the illusionary nature of its founding premise, that is, of the cultural autonomy of Art within bourgeois culture.

Photography, on the other hand, while contributing to the conditions of Modernist art practice by freeing painting or usurping from painting, as the case may be, its traditional representational function, had nonetheless developed (at least in America) in virtual isolation from the mainstream of Modernist art. That singular artists such as Alfred Stieglitz, László Moholy-Nagy, or Man Ray may be said to have in part bridged that gap and participated in both worlds, or that work of great artistic merit (or quality) may have been produced in the photographic medium, does not vitiate the fact that, in the most basic

sense, the assumptions underlying the development of painting and sculpture during the last one hundred years are fundamentally different from those that determined the development of photography. The hermeticism, the self-reflexivity, and the vanguardist posture, which are the hallmarks of Modernist theology, could not be more dissimilar to the wide-eyed precious sensitivity that modern photographers exhibited toward the ever-expanding content of their one true subject: the objective world, as is.

The fact that photography was an inherently mechanical and reproducible medium has long been forwarded as the apparent explanation for this phenomenon. That photography was a primarily scientific invention, whose high commercial viability reinforced a self-assumptive technological and functionalist approach to the medium on the part of professional (i.e., commercial) and nonprofessional (i.e., amateur) practitioners has doubtlessly contributed to the relative banality of photography as a popular medium. Yet it is really the attributes of photography's representational credibility (or veracity), combined with its suitability for reproduction (and I do not mean reproduction in the sense of unique versus multiple-edition artworks, but reproduction in the likewise modern systems of information distribution, printing, and electronic transmission), which have provided a context for the development of photography within this century that is so far-reaching as to have entirely transformed the very meaning of visual culture.

Photography has become almost a second language, integrated as the written and spoken word into almost every aspect of social production. The extent and import of photography's effect on modern culture, combined with the uncritical functionality of its commercial applications, seem strangely at odds with the quaint purism of that which we call "fine art photography." Indeed the whole tradition of that which is called Modernism in photography seems to have evolved around a rather mistaken attempt to seek legitimization as "an art form" from a Modernist tradition with which it had ideologically very little in common. That "fine art photographers" shared with their Modernist peers an exaggerated posture of refined disdain for commerce only underlines the naïveté of such a blatantly contradictory self-definition. To beg the question of whether photography can rightly be considered "an art form" is to enframe the inquiry from an almost pre-Modernist conception of Art, a conception from which the term "fine" still lingers as an anachronism—that is, the tradition of Beaux-Arts, wherein the academy stands in judgment over the various "branches" of "fine" art (media), passing out laurels to the most excellent exemplars of academic achievement.

Inasmuch as there was an academy that administered over Modernism in America—I am referring of course to the Museum of Modern Art—the academy really went quite far out of its way to welcome the new medium into the academic fold. This, however, didn't do much to charge the lifeblood of the juvenile aesthetic. To me, to ask whether a photograph by virtue of its medium can or cannot be considered Art is like asking whether paint or wood or metal or plastic can be Art. This question never occurred to Picasso (Pop Modernism's artist par excellence) any more than it did to Duchamp or Smithson or Warhol; or more accurately the falsity of this conception was vividly demonstrated through

their work, as it was through the body of Modernist art practice. Meret Oppenheim did not ask the academy if fur-lined teacups were an acceptable medium for Modern art. *Art is not defined by the medium it employs but rather by the questions that it asks*, by the propositions that it makes regarding its own nature as well as the nature of its world.

Being perhaps nurtured on Modernism, I still hold the highest respect for those individuals—whether they be painters, writers, photographers, or scientists—who probe and provoke the given languages of our society—whether they be literate or pictorial—to find expression of that which lies beyond the known, the given, or the apparent of the visible world and the established social order.

My involvement with photography, which has been the main focus of my artwork for approximately eight years, did not come about through an interest in cameras, or through a love of taking pictures (a hobby that I practiced professionally as a supplementary source of income). It comes rather from a lifelong involvement with Art, its history, and its multifaceted production; it comes from a belief, and I think it is proper to say "fathered in Modernism," that Art must find the forms to know and name its time. It is through an early involvement with painting, and through the profound influence of Conceptual art on my thinking as a student, that I turned to photography not so much as a medium, but as a subject, if not the rightful subject, of visual art. If Pop and Conceptual art left Modernism on the brink of culture at large, Post-Conceptual art turns away from its hermetic past to embrace culture itself as its legitimate subject. Unlike what we have been led to believe of painting, photography is blatantly at peace with commerce. While "fine art photography" recognizes as its legitimate subject such things as cows, doorways, workers, faces, and church steeples, I find myself living increasingly in a world made of images, photos, television, movies…images of love and war and violence; images of death; images of distant lands, the past, the future, galaxies beyond the sight of human eyes, and fantasia worlds of animals that live beneath the sea. I lived through a war I never saw except through photographs and broadcast news reports. I saw the president of my country shot on TV, and I saw his assassin shot live on TV.

These images are the things of which my psychic environment is made, perhaps even more than the tables and chairs that make up the physical architecture of my personal world. While the tradition of photography stresses integrity in the form of a passive and almost documentary purism, which aestheticizes the given (clearly a doctrine of non-intervention—it is only in advertising photography that we allow the world to be manipulated), art asks: What is photography? What is the nature of this medium? What does it signify through its presence in our lives? What are its conventions? Its syntax? What are the values that it represents? What does it deny? To live in a world of photographs is to live in a world of substitutes, stand-ins, representations of things, or so it seems, whose actual referents are always the other, the described, the reality of a world once removed. I prefer, on the other hand, to look at the photograph as something real and of my world—a strange and powerful thing—but not a thing to be viewed in isolation, but as part of a language, a system of communication, an economy of signs.

I do not want to digress into the issue of language (an extremely complex affair on its own), but will point out that a language is defined by the conventions it employs. To me, photography has become a language. And it is perhaps only at this point in history that we are capable of saying this, at a time when conventions have become established, when conventions can begin to have significant force in their own right—that through the self-conscious use of convention, secondary meanings can be expressed. It is through the delineation of language, through the ability to signify and not merely replicate through form, that photography begins to broach the power of Art. The power of Art resides not merely in the power to represent, but in the power to intend, to reveal a self-conscious relation to that which is represented or expressed. This is a power that strives to make and not merely replicate the world.

It is this issue of representation that brings me full circle to the question of Postmodernism. While I am loath to identify myself with such an apparently undirected practice as the term implies (i.e., everything since Modernism), and I am not even sure that what we are now calling Postmodernism is not really, in many senses, just another swing of the dialectic, rather than some marking point between two diverse historical modes, I do recognize around me the contours of a photographic practice that is fundamentally different from either mainstream Modernist art or traditional "fine art photography." This practice, and I include myself along with Laurie Simmons and Richard Prince, and a number others such as Cindy Sherman, Barbara Kruger, James Casebere, Sherrie Levine, and so on, shares common origins in non-photographic, cinematic, and even painterly representation. Key words such as appropriation, intervention, and fabrication are frequently bantered about as indicative traits of new or "Postmodern" photography. But none of these things are new or innovative approaches in themselves. They are just devices, ways of making images—making ideas and making connections. Photography itself is just such a device, a way of making an image. It is the images and the ideas that count. It is what they say, not only about photography, not only about art or representation, but about the very values that visual culture itself, as a Pop object, projects (and I include art history in Pop). It is not only images that are "appropriated," but styles and kinds of images. New directorial photography (images that are constructed or staged) such as Cindy Sherman's or James Casebere's remind us not only of the "look" of mass culture, but of the actual constructive process by which it is made. Pop art pointed out that popular culture existed and was not in itself lethal to Art. Postmodernism is increasingly a part of that culture. But it is a critical part.

The artificial, the posed, the stylized, the familiar are not so much a threat to this art, but a rich and rigorous syntax of social exchange and personal experience. To reveal through exploration and expression of convention its structures and meaning, its language of form, is a step toward consciousness within.

*Edited transcription from Sarah Charlesworth's unpublished, typewritten notes for the panel. It has been largely preserved in its original state as a historical document.

Representation, then, is not—nor can it be—neutral; it is an act —indeed the founding act—of power in our culture.

—*Craig Ownes*

Though shalt not make unto thee any graven image, or any likeness of any thing that is in the earth beneath, or that is in the water under the earth: thou shalt not bow down thyself to them; nor serve them . . .

—*God*

Deprived of narrative, representation alone, as signifying device, operates as guarantee for the mythic community: it appears as symptomatic of the pictorial works adherence to an ideology; but it also represents the opposite side of the norm, the antinorm, the forbidden, the anomalous, the excessive, and the repressed: Hell.

—*Julia Kristeva*

The desire of representation exists only insofar as the original is always deferred. It is only in th absence of the original that representation takes place, because it is already there in the world as representation.

—*Douglas Crimp*

Every cigarette, every drink, every love affair echoes down a never-ending passageway of references—to advertisements, to television shows, to movies—to the point where we no longer know if we mimic or are mimicked.

—*Tom Lawson*

Relationship between human beings is based on the image-forming, defensive mechanism. In our relationships each of us builds an image about the other and these two images have relationship, not the human beings themselves . . . One has an image about one's country and about oneself, and we are always strengthening these images by adding more and more to them. And it is these images which have relationship. The actual relationship between two human beings completely end when there is a formation of images . . . All our relationships, whether they be property, ideas or people, are based essentially on this image-forming, and hence there is always a conflict.

—*Krishnamurti*

Where the real world changes into simple images, the simple images become real beings and effective motivations of hypnotic behavior.

—*Guy Debord*

The acquisition of my tape recorder (camera) really finished whatever emotional life I might have had, but I was glad to see it go. Nothing was ever a problem again, because a problem just meant a good tape (photo), and when a problem transforms itself into a good tape (photo) its not a problem anymore. An interesting problem was an interesting tape (photo). Everybody knew that and performed for the tape (photo). You couldn't tell which problems were real and which problems were exaggerated for the tape (photo). Better yet, the people telling you the problems couldn't decide anymore if they were really having problems or if they were just performing.

—*Andy Warhol*

The objects which the image presents to us and to which our only relation can be that of possession, necessarily represents our being, our situation in the world. The libidinal investment in the image, an investment on which the economic investment turns, is profoundly narcissistic, and avoidance of the problem of the other.

—*Colin MacCabe*

The photographs have a reality for me that the people don't. It's through the photograph that I know them. Maybe it's in the nature of being a photographer. I'm really never implicated. I don't have any real knowledge.

—*Richard Avedon*

Incapable of producing metaphors by means of signs alone, he (the phobic person) produces them in the very material of drives —and it turns out that the only rhetoric of which he is capable is that of affect, and it is projected, as often as not, by means of images.

—*Julia Kristeva*

. . . the image is treated as a stand-in or as a replacement for someone who would not otherwise appear . . .

—*Craig Owens*

All art is "image making" and all image making is the creation of substitutes.

—*E.H. Gombrich*

In a world which is topsy-turvy, the true is a moment of false.

—*Guy Debord*

Photography today seems to be in a state of flight . . . The amateur forces his Sundays into a series of unnatural poses.

—*Dorothea Lange*

The destiny of photography has taken it far beyond the role to which it was originally thought to be limited; to give more accurate reports on reality (including works of art). Photography is the reality; the real object is often exerienced as a letdown. Photographs make normative an experience of art that is mediated, second-hand, intense in a different way.

—*Susan Sontag*

To see and to show, is the mission now undertaken by LIFE. (magazine)

—*Henry Luce*

The literal photograph reduces us to the scandal of horror, not to horror itself.

—*Roland Barthes*

People were murdered for the camera; and some photographers and a television camera crew departed without taking a picture in the hope that in the absence of cameramen acts might not be committed. Others felt that the mob was beyond appeal to mercy. They stayed and won Pulitzer Prizes. Were they right?

—*Harold Evans*

Distanciation is this: going all the way in the representation to the point where the meaning is no longer the truth of the actor but the political relation of the situation.

—*Roland Barthes*

The world is centered for us by the camera and we are at the center of a world always in focus. As long as we accept this centering we shall never be able to pose the question of "who speaks" in the image, never be able to understand the dictation of our place.

—*Colin MacCabe*

A clear boundary has been drawn between photography and its social character. In other words, the ills of photography are the ills of estheticism. Estheticism must be superceded, in its entirety, for a meaningful art, of any sort, to emerge.

—*Allan Sekula*

Our conviction that we are free to choose what we make of a

SARAH CHARLESWORTH

LA- LIA

photograph hides the complicity to which we are recruited in the very act of looking.

—Victor Burgin

For the first time in world history, mechanical reproduction emancipates the work of art from its parasitical dependence on ritual. To an even greater degree the work of art reproduced becomes the work of art designed for reproducibility.

—Walter Benjamin

. . . for the modern photographer the end product of his efforts is the printed page, not the photographic print.

—Irving Penn

Much of painting today aspires to the qualities of reproducible objects. Finally, photographs have become so much the leading visual experience that we now have works of art which are produced in order to be photographed.

—Susan Sontag

For a certain moment photography enters the practice of art in such a way that it contaminates the purity of modernism's seperate categories, the categories of paint and sculpture. These categories are subsequently divested of their fictive autonomy, their idealism, and thus their power.

—Douglas Crimp

The morphology of photograpy would have been vastly different had photographers resisted the urge to acquire the credentials of esthetic respectability for their meduim, and instead simply pursued it as a way of producing evidence of intelligent life on earth.

—A.D. Coleman

For every photographer who clamors to make it as an artist, there is an artist running the risk of turning into a photographer.

—Nancy Foote

Photography is better than art. It is a solar phenomenon in which the artist collaborates with the sun.

—Lamartine

The photographic artists' downfall is the romance with technique.

—Carol Squiers

The creative in photography is its capitulation to fashion. The world is beautiful. That is its watchword.

—Walter Benjamin

While the aesthetics of consumption (photographic or otherwise) requires a heroicized myth of the artist, the exemplary practice of the player-off codes requires only an operator, a producer, a scriptor, or a pasticheur.

—Abigail Solomon Godeau

Montage before shooting, montage during shooting and montage after shooting.

—The Dziga Vertov Group

A work that does not dominate reality and that does not allow the public to dominate it is not a work of art.

—Bertolt Brecht

A certain contempt for the material employed to express an idea is indispensible to the purist realization of this idea.

—Man Ray

You know exactly what I think of photography. I would like to see it make people despise painting until something else would make photography unbearable. —Marcel Duchamp

. . . the very question of whether photography is or is not an art is essentially a misleading one. Although photography generates works that can be called art—it requires subjectivity, it can lie, it gives aesthetic pleasure—photography is not, to begin with, an art form at all. Like language, it is a medium in which works of art (among other things) are made

—Susan Sontag

The blatantly mechanistic condition bound to photographic seeing has confounded photographic discourse. One-way thinking has stratified this moonlighting medium ever since its invention, zoning it into polemic ghettos walled off by hegemonies and hierarchies.

—Ingrid Sischy

It is a fetishistic and fundamentally anti-technical notion of art with which theorists of photography have tusseled for almost a century, without of course acheiving the slightest result! For they sought nothing beyond acquiring credentials for the photographer from the judgement-seat he had already overturned.

—Walter Benjamin

That photography had overturned the judgement-seat of art is a fact which the discourse of modernism found it necessary to repress, and so it seems that we may say of postmodernism that it constitutes the return of the repressed. These institutions can be named at the outset: first the museums; then Art History; and finally, in a more complex sense, because modernism depends both on its presence and upon its absence, photography.

—Douglas Crimp

The postmodernist critique of representation undermines the referential status of visual imagery, its claim to represent reality as it really is —either the appearance of things or some ideal order behind or beyond appearance.

—Craig Owens

Quotation has mediation as its essence, if not its primary concern, and any claims for objectivity or accuracy are in relation to representations of representations, not representations of truth.

—Martha Rosler

Perception that stops at the surface has forgotten the labyrinth of the visible.

—Ingrid Sischy and Germano Celant

In order for history to be truthfully represented, the mere surface offered by the photograph must somehow be disrupted.

—Siegfried Kracauer

The intention of the artist must therefore be to unsettle conventional thought from within, to cast doubt on the normalized perception of the "natural" by destabilizing the means used to represent it.

—Tom Lawson

To reframe is of course to represent that which I have seen . . . to represent the process by which vision projects and transforms itself, to engage in the struggle to discover that which is absent, obscured from our vision, through an encounter with that which is manifest, given. —Sarah Charlesworth

To photograph is to confer importance. There is probably no subject that cannot be beautified; moreover, there is no way to suppress the tendency inherent in all photographs to accord value to their subjects. But the value itself can be altered . . .

—Susan Sontag

AND BARBARA KRUGER

61

Left page, SARAH CHARLESWORTH

CINDY SHERMAN

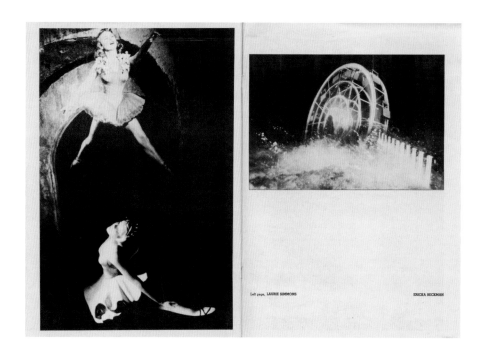

Left page, LAURIE SIMMONS

ERICKA BECKMAN

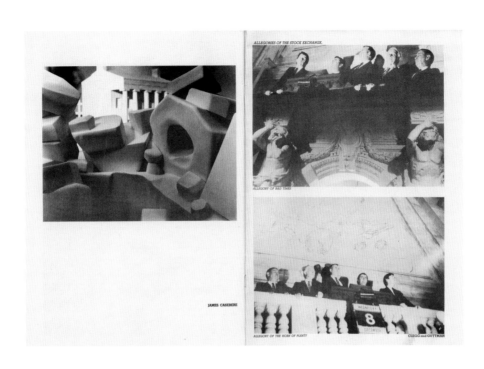

ALLEGORIES OF THE STOCK EXCHANGE,

ALLEGORY OF BAD TIMES

JAMES CASEBERE

ALLEGORY OF THE HORN OF PLENTY CLEGG and GUTTMAN

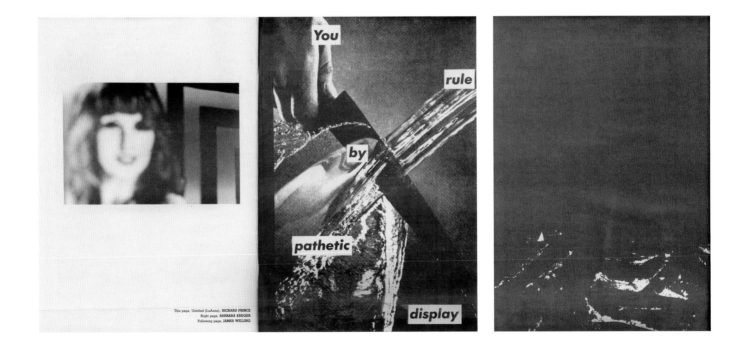

You
rule
by
pathetic
display

This page, Untitled (LuAnne), RICHARD PRINCE
Right page, BARBARA KRUGER
Following page, JAMES WELLING

Sarah Charlesworth: An Interview

David Clarkson

DAVID CLARKSON: Your work is often critically associated with "neo-Conceptualism"; how does this critically differ from Conceptual art of the past?

SARAH CHARLESWORTH: "Neo-Conceptualism" is a kind of grab-bag word that people have been using to apply to all sorts of work that has some kind of rational theoretical structure behind it. It's applied to almost all work that isn't directly expressionistic. When Conceptual art first emerged, the *idea* of the work, the idea of "Art as Idea," was what was proffered and important, and the physical manifestation was only a vehicle to indicate that idea. "Documentation" was the word used in conjunction with Conceptualism. Artists would use a map, a photograph, a diagram, or a list to indicate some ideal structure. This document was not supposed to function as an artwork itself, but to indicate an "idea" that was "invisible." I think that that was naïve, in a way. In our historical perspective, we've come to realize that if there's a physical object present, then that's what we're engaged with: idea-generative or not. In a sense, ideas can be created with a physical object, but the nature of the physicality has to do with the nature of the idea that you're generating. In my work, the seductive quality of the object is very much related to the concept behind the work itself.

DC: It seems also related to the world of advertising, or at least to the mechanism of the mass media advertisement.

SC: I think so too. One of the strategies of my work is to borrow techniques or modes of presentation from advertisements or commercial art. This is done to reveal the way in which the seduction process of images functions. In the earliest pieces (in my ongoing series called "Objects of Desire" [1983–88]), the idea of "desire" referred to the desire that was conjured, or appealed to, in the viewer. The "object" was the vehicle…the art object, the advertisement, the clothing, the device through which desire was articulated, stimulated. I would use clothes and makeup, the outer trappings of the human subject, and by removing the human being from them, show the way in which the social code (the clothes, the pose) precedes the individual who occupies it. Thus, in a sense, mass culture establishes roles that we come to identify with.

DC: Would it be fair to say that those pictures are representations *of* identities? Or is their representation more complex?

SC: They are not representations of specific identities, but rather of codes or models through which individuals negotiate their particular styles or attitudes. But the meaning of desire, the kind of desire that I'm addressing, has shifted from series to series. The first series, which was about alienation and seduction, was red and black. It dealt specifically with sexual desire and was gender-related. There were many male and female figures about which one was supposed to say either: "Gee, I'd like to look like that!" or "That guy is really a creep." You were constantly turning on and turning off to these various forms. In the second series, which was green and black, the theme was about desire for natural origins, our culture's myth of nature. I used idealized *National Geographic*–type figures. These works didn't have to do with actual origins, just with our own image of where we come from, or a desire to connect ourselves with some concept of ongoing nature. We live in an image-world that's populated by native girls with flowered necklaces and shells and beads in their hair, and with lions and tigers, and masculine black guys beating drums. In the third series, the concern is with an almost ontological desire for meaning. So, the objects are no longer clothing or native dancers, but rather godheads or classical icons, mandalas or altarpieces, some "real" and some "made up" by me. I used objects that came from art history or archeology. The desire in this case is the desire for a god, the desire for an icon.

DC: You've used dichotomies as principal organizing structures in much of your work—fragmentation/wholeness, masculinity/femininity, nature/culture, presence/absence—yet there seems to be no simple oppositional set at the core of these pictures you've just mentioned.

SC: In the first series, I was specifically concerned with gender, with sexuality. A male/female opposition was a given factor. So, I did use turn-on/turn-off–, seduction/alienation–type images. The "theme" structured the oppositional quality. The work in the second series, which was concerned with the romance of nature, didn't work in oppositional sets so clearly. In fact, the major piece in that series was a triptych. I found it interesting that the difference in theme established a difference in form. I think that these newer pieces, more concerned with an ontology, a search for God or an ultimate icon, function more individually. It's been a sort of goal for me to get to a point where one piece is one piece and doesn't need another piece to contextualize it. Though, there is one piece in the "Objects of Desire" series at S.L. Simpson Gallery that could be considered an opposition, but not a direct one. It's the piece with two panels: on one is a bowl, and on the other is a column. In a way, it goes back to gender opposition, but metaphorically, not explicitly. Isolated from any other visual social context, that reading is automatic. It is given, and implicit, in the culture itself. The piece is not in opposition in

the sense that, say, the red mask and the black mask were the mask of seduction and the mask of alienation. This is not deliberately an opposition, merely a difference. Both panels have a blue ground, and the function of the piece is more abstract than in the earlier red and black pieces.

DC: I am more interested in the kinds of relationships that occur within these newer pieces simply because, for me anyway, the very idea of such specific terms of absolute difference doesn't seem to make much sense anymore. They seem to crumble away in the face of simulation. When working with a re-presentation of referents, where they are literally cut away from any original context, their reference is seen to be far more complex than the simple stability that a dichotomy implies. It's more a process of adaptation and generation.

SC: That is part of the point. The pieces are deliberately extracted, context-less. I think that this is exaggerated by the fact that I often don't remember what culture some object that I've used comes from. This is very much a postmodern amnesia. There's a deliberate kind of, I don't know that you could call it "denial," but certainly an ignoring of what the initial context is and a recontextualizing. That's the way that images function in mass culture, and I'm trying to exaggerate that. They stand for things, and we don't need to know exactly where they came from. *We use them for what we want them to mean.*

DC: I agree that that's how we generally approach images, especially from the mass media. But isn't this a sort of colonialism, when we're not concerned about their authenticity or, simply said, about the "real" history that generated initial meaning for these images?

SC: Well, I think that "real history" is a fiction anyway, so I'm exaggerating that fiction. Certainly, an Egyptian statue in an Egyptian museum, studied by an Egyptologist, has a different significance than the "Egyptian" figure that I've used in one of my pieces. I don't know of whom the statue is, Amenhotep IV or something like that, or from what dynasty it comes. I just call it "The Sphinx" because that's how it's going to function in my vocabulary. It admits a question but not a clear answer. I think of myself as a robber or something. I plunder and pillage on paper. I like the fact that I can have anything I want out of all time and place (that I can get via image form) as mine. I possess these things and give them my own meaning. This is very different from what an art historian does, which is to try to approach some description of what the original meaning was. I'm using images that are available in my culture, and I'm using them for my own purposes in order to describe a state, a cultural state, a state of mind, that is meaningful to me.

DC: Do you really think of it so expressively? You seemed to indicate that you were expressing a particular, personal message *through* an image to an audience.

SC: I see myself as being perfectly balanced between being a recipient of these images, and being a maker of them—being passive and active in relation to the work. I don't set out to express an emotion and then go looking for images to express it. Nor do I simply take an image and do a reading of it. I'm trying to let the image reveal its own nature; in the process, it reveals mine.

DC: So you don't "express yourself" in the conventional sense.

SC: There's always an emotional drive behind any kind of work, no matter how apparently neutral or analytic, critical or polemic. In the earliest "Objects of Desire" works, I was definitely angry about sexual-role stereotyping via the mass media. But while there is always a drive to begin with, I think that the final product is often more ambiguous. The objects that I create don't argue an argument, but rather set up a question—set up a sort of ambiguous relation with an image that is at once both desire and alienation. It's meant to heighten the question, not deliver an answer. It proposes a continual process of self-examination and doesn't clearly deliver a position that's free from compromise. I'm aware of my own entrenchment within a whole system of values that I'm trying to criticize.

DC: Images always seem to implicate us. You can't extricate yourself from their reference.

SC: In one sense, we live in a regular three-dimensional physical world, and in another sense, we inhabit an entirely different image-world. I think that all my work situates itself within a landscape of images. I see photography as a dominant language of contemporary culture. It's at least equal to the impact of written or spoken language. This is a situation without historical precedent, and that's the reason why, as a contemporary artist, I feel it's a primary issue. The reason why I use what are commonly called "appropriated images," images drawn from popular culture, is because I wish to describe and address a state of mind that is a direct product of living in a common world. While the three-dimensional world and the image-world are physically distinct, there is a kind of conceptual osmosis, a reciprocity of meaning between the two. The image repertoire that is yours and mine via popular culture is something we share: *a common vocabulary*. Therefore, when I use these images I'm not expressing myself, my private inner feelings, but rather I'm drawing from something that is common and shared. I think that this provides a link with the viewer of the work and myself, in the sense that we're both subject to the kinds of images that I use as an artist. It's the commonality of the landscape that I'm describing, not a private mindscape.

Images of the first man on the moon, or images of President Kennedy being shot, or fashion photos, Calvin Klein ads, these are certain images that are part of our "real" environment. I think that what we're so awkwardly approaching is a totally different state of culture than that which we've previously known. It's a metaphysical problem. I wonder about the true metaphysical state of living with images that are shared and propagated

by the hundreds of thousands. Part of the feeling we have, you and I, of being inarticulate in approaching these issues is that we, in fact, lack the vocabulary. We lack the conceptual structure.

That's exactly what I'm trying to uncover and broach in my work. Over and over again, I'm talking about problems of representation, and I can barely get through the elements to stand still long enough to talk about them. I think that it's really because it's a new Being-in-the-World. It *is* a new phenomenon.

DC: The great problem is that we seem forced to understand this collapse of transmission and reception through a vestigial vocabulary based on notions of "originality," "authenticity," "subjectivity," and so on. We have to push these remnants to the point of mutation.

SC: Even when Walter Benjamin talked about "Art in the Age of Mechanical Reproduction," he was talking about multiple copies versus unique objects. We are not even talking about multiple copies. We are talking about the global, electronic, computerized, satellite-dish transmission of images, reaching millions of people! Images themselves are traveling at the speed of light…well, at least sound. This is an entirely new, not only metaphysical frontier, but a political and social frontier as well. I think that we're pioneers in terms of trying to approach a conceptual grasp of what this means. Some of these new words that have come up—it's almost as if culture itself has become abstracted to the point where it's extremely difficult for a person to even conceive of the way in which they exist in it. We live in a transcultural state wherein culture itself has become self-conscious of itself as culture. It's abstraction already.

Compare this with a more localized culture in which you have your set of traditions and costumes and food. We choose between Chinese or Italian for dinner, or whether to wear our Japanese designer clothes or read our French philosophy. We live in a "hyper-" (or "meta-") culture that borrows geographically and socially from a number of different (originally local) cultures that have become almost *free-floating* in a media culture. I don't belong anymore to an authentic, original culture. If there's a way to describe my culture, it's as a pop culture, which is a metaculture.

DC: We have our customs and costumes nonetheless.

SC: Yeah, like Benetton sweater franchises all over the world where you choose from an international vocabulary. The Japanese buy jeans, and we buy kimonos. I think that there's a kind of carnival-of-history atmosphere about these last works. One of the things that interests me is the *variety* of historical and political phenomena that we, and our culture, are subject to via photography. But images are real, not just "stand-ins" for objects. Before, when I said that I think of myself as a robber, I wasn't talking about "copyright." It's not the political act of appropriation that interests me, but rather the fact that I can take what I wish from culture toward my own ends. It sounds imperialistic, but all I'm

taking are pieces of paper, which are already mine by virtue of the fact that they are on my floor or worktable. I bought the magazines. Once they are transmitted into my environment, I allow myself the freedom to react to them, to respond to them, to alter them, in keeping with my own desires, directed toward the human goals…the values I support.

Originally published in *Parachute*, December 1987.

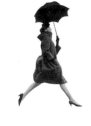
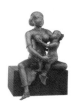

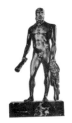

0+1

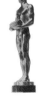

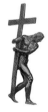
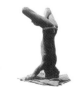
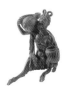

pp. 110–11: *Figure Drawings*, 1988/2008

NEVERLAND

Candle, 2002

WORK IN PROGRESS

Camera Work, 2009

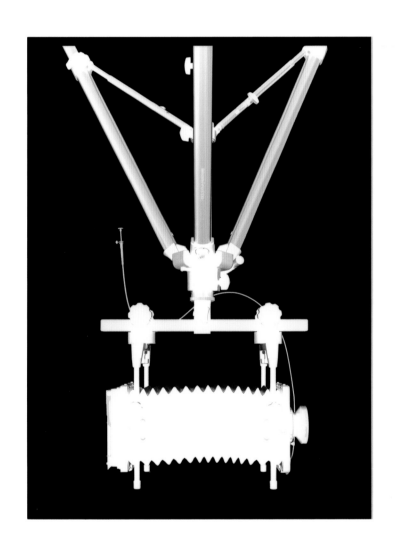

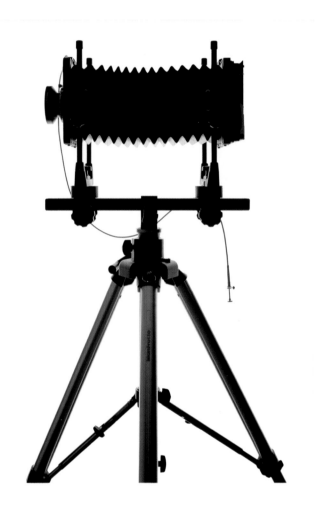

AVAILABLE LIGHT

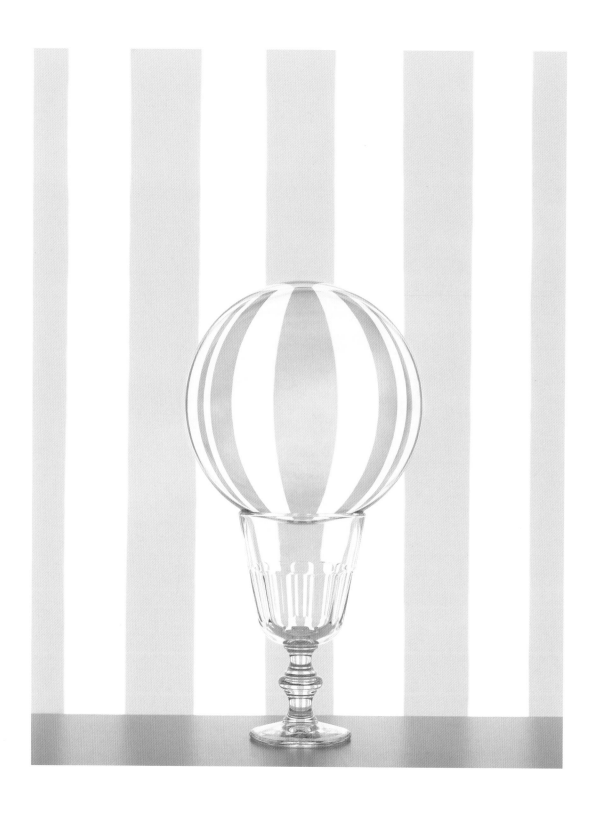

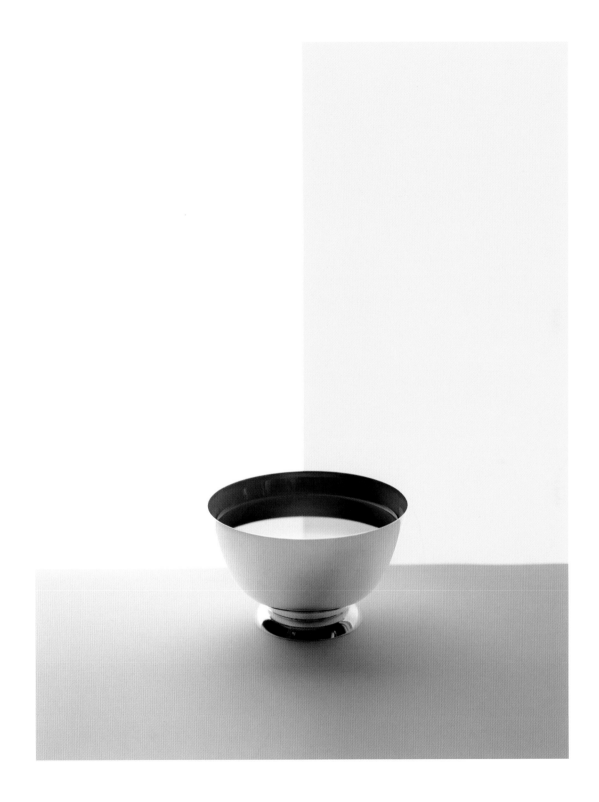

MODERN HISTORY

• edizione
straordinaria

Il Messaggero
di Roma

• edizione
straordinaria

Anno 100 N. 107 S. Adalgisa vergine © Spediz. abbonamento postale Gruppo 1/70 Il Giornale del mattino Un numero L. 200 Giovedì 20 aprile 1978

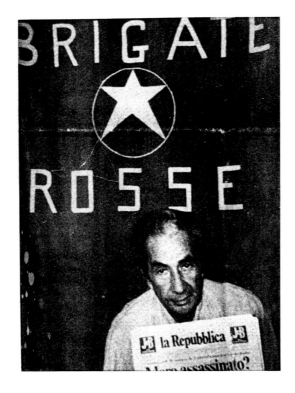

J&B rare scotch whisky

la Repubblica

Direttore Eugenio Scalfari

J&B rare scotch whisky

Anno 3 - Numero 93 - L. 200

Redazione, Amministrazione: 00185 ROMA, Piazza Indipendenza, 11-b, tel. 497941 telex 68180-64005 (can. post. 2412 Roma AD Sped. in abb. post. gr. 1/70 — Abbonamenti: ITALIA (c.c.p. n. 11200003 - Roma) anno L. 40.000, semestre 25.000, trimestre 15.000 - ESTERO: anno 80.500, semestre 41.500, trimestre 21.500 (posta ordinaria) — Copia arretrata L. 400 — Redazione di Milano, via Turati 3, tel. 638525 - 6571717 - telex 25283 Concessionaria per la pubblicità: A. MANZONI & C. S.p.A., 20121 MILANO - via Agnello 12

mercoledì 19 aprile 1978

Un messaggio delle Br annuncia che il cadavere si trova in un lago del Reatino

Moro assassinato?

Vane le ricerche di elicotteri e sommozzatori
Non si esclude l'ipotesi di una falsa pista

Il luogo indicato è inaccessibile per la grande quantità di neve.
Solo con gli elicotteri è stato possibile raggiungerlo. Se il comunicato
dei terroristi è veritiero il presidente della Dc sarebbe
stato ucciso da diversi giorni e il suo corpo affondato

Il paese è compatto

NON CI POTEVA essere un 18 aprile più tremendamente fosco di quello che abbiamo passato: l'annuncio dell'assassinio, il pensiero di quel corpo affondato in un lago ghiacciato come la morte, il sadismo di quel comunicato, l'irruzione nel covo dei brigatisti al decimo chilometro della Cassia, carabinieri e polizia agli sbocchi delle strade del centro di Roma, Zaccagnini in lacrime, la famiglia di Moro impietrita nel dolore.

Nel momento in cui scriviamo, ancora s'ignora se l'ultimo messaggio delle Br sia autentico, sebbene l'opinione degli inquirenti propenda per il sì. Ma autentico non vuol dire necessariamente veridico. Le ipotesi che attualmente s'intrecciano — fino a quando il piccolo lago della Duchessa non sarà stato interamente esplorato e dragato — sono dunque le seguenti:

1) Il volantino delle Br è un falso materiale, compiuto da un gruppo di macabri ignoti, desiderosi di "punire" la Dc nel giorno anniversario della sua vittoria politica di trent'anni fa. Quest'ipotesi non sembra credibile.

2) Il volantino è autentico e veritiero: il corpo di Moro è là, sotto quell'acqua gelata, sulla cima del Velino! Oggi o al massimo domani dovremo averne conferma.

3) Il volantino è autentico ma non veritiero. E' servito cioè a distrarre per alcune ore l'attenzione degli inquirenti, a "depistarli" verso un obiettivo falso per consentire nel frattempo ai brigatisti di cambiare zona, rompere la stretta delle indagini e proseguire da 'n luogo più sicuro l'azione intrapresa il 16 marzo.

SEGUE A PAGINA 2

Oggi si ricomincia tra neve e ghiaccio
di PAOLO GUZZANTI

RIETI — Prima delle 19 le ricerche del corpo di Aldo Moro al lago della Duchessa sono state sospese. Le prime ricognizioni non hanno dato alcun risultato. E' forte il sospetto che il contenuto del settimo messaggio delle brigate rosse sia falso. Se fosse invece vero, è il corpo del presidente della Democrazia cristiana si trovasse realmente sepolto nelle gelide acque del laghetto, si dovrebbe accettare una delle seguenti ipotesi: Aldo Moro è morto da diversi giorni ed il suo corpo è stato affondato nel lago durante la scorsa settimana. Oppure, ipotesi: Aldo Moro è morto da diversi giorni con un elicottero e gettato giù. Ciò che spinge a queste conclusioni è l'assoluta mancanza di tracce sulla neve che circonda lo specchio d'acqua.

SEGUE A PAGINA 2

Tragico 18 aprile a Piazza del Gesù
di GIAMPAOLO PANSA

ROMA — Doveva arrivare, questo 18 aprile a piazza del Gesù, ma nessuno lo immaginava così carico d'angoscia, così straziato fra notizie vere e notizie incerte, così crudele nell'alternarsi dei messaggi di morte e dei lampi di speranza. La prima telefonata, alle 10,30, è di Lettieri, sottosegretario all'Interno; c'è l'ultimo comunicato delle Brigate Rosse, Moro è stato assassinato. Zaccagnini ascolta, con lui c'è soltanto Pisanu, il capo della sua segreteria politica. E noi, adesso, siamo tutti qui col taccuino in mano, a torchiare Pisanu, per sapere le solite cose inutili e un po' feroci. Com'era Zac? Che cosa ha fatto Zac? Che cosa ha mormorato Zac? Pisanu ci fissa senza vederci, poi replica: «Zaccagnini non ha detto niente».

SEGUE A PAGINA 4

Annuncia l'esecuzione
Questo il testo del comunicato n. 7

ROMA — Ecco il testo del comunicato n. 7 inviato dalle Brigate rosse al «Messaggero».

«Il processo ad Aldo Moro «Oggi 18 aprile 1978, si conclude il periodo "dittatoriale" della Dc che per ben trent'anni ha tristemente dominato con la logica del sopruso. In concomitanza con questa data comunichiamo l'avvenuta esecuzione del presidente della Dc Aldo Moro, mediante "suicidio". Consentiamo il recupero della salma, fornendo l'esatto luogo ove egli giace. La salma di Aldo Moro è immersa nei fondali limacciosi (ecco perché si dichiarava impantanato) del lago Duchessa, alt. mt. 1800 circa località Carlore (RI) zona confinante tra Abruzzo e Lazio.

«E' soltanto l'inizio di una lunga serie di "suicidi": il "suicidio" non deve essere soltanto una "prerogativa" esclusiva del gruppo Baader Meinhof. «Inizino a tremare per le loro malefatte i vari Cossiga, Andreotti, Taviani e tutti coloro i quali sostengono il regime.

«P.S. - Rammentiamo ai vari Sossi, Barbaro, Corsi, ecc. che sono sempre sottoposti a libertà "vigilata".

«Comunicato n. 7 18-4-1978 «Per il comunismo Brigate rosse».

La polizia arriva per caso al covo terrorista nella periferia di Roma

Scoperta la base delle Br
Armi, esplosivi, divise, documenti

Berlinguer da Zaccagnini

ROMA — Il comitato centrale comunista che discuteva sulla lotta contro il terrorismo è stato sospeso, tutti i dirigenti sono partiti per raggiungere le sedi di partito. Berlinguer e Chiaromonte, dopo una riunione straordinaria della Direzione, sono andati a piazza del Gesù per esprimere a Zaccagnini la solidarietà del Pci. Sospeso anche il congresso della Fgci che deve cominciare oggi a Firenze. Bufalini ha letto una dichiarazione che impegna il Pci ad un'azione di massa per isolare i terroristi. Cossutta dichiara: «E' un atto di guerra».

IL SERVIZIO A PAGINA 4

ROMA — Una base terroristica di estrema importanza è stata scoperta — quasi casualmente — nella mattinata di ieri in via Gradoli, a tre chilometri in linea d'aria da via Fani, dove fu rapito Moro. Ad accorgersi del covo sono stati i vigili del fuoco, chiamati da un inquilino che aveva l'appartamento invaso dall'acqua proveniente dall'alloggio soprastante. Quest'ultimo s'è rivelato come un vero arsenale-magazzino dei terroristi: oltre a pistole, bombe a mano, mitra, ordigni fumogeni e lacrimogeni della polizia, sono state trovate divise dell'Alitalia, da operai della Sip, camici bianchi, divise da poliziotto, targhe rubate, carte d'identità, tessere ferroviarie di sconto.

L'alloggio era abitato da un trentacinquenne, non tanto alto, robusto, che diceva di chiamarsi Borghi. All'arrivo della polizia è stata vista una ragazza allontanarsi su una moto di grossa cilindrata, invertendo la direzione di marcia; anche un uomo sarebbe fuggito dalla parte opposta. Secondo alcuni testimoni nel minuscolo appartamento di via Gradoli, notte fra lunedì e martedì, qualcuno ha battuto a macchina a lungo. Forse un nuovo messaggio delle Br? Pare accertato infine che sempre la notte scorsa, insieme al misterioso signor Borghi, si trovasse anche una ragazza.

I SERVIZI A PAGG. 2-3

I due massimi scrittori italiani condannano i terroristi
"Le loro azioni ci fanno orrore"
di ALBERTO MORAVIA

COMUNQUE vada a finire, siamo arrivati all'ultimo atto di questa losca vicenda. In un momento come questo accetto volentieri l'invito a ripetere la mia opinione.

Sono stato in Unione Sovietica e in Cina e ho profonda ammirazione per le due rivoluzioni che ci sono state in quei paesi. Credo anche però che a quelle rivoluzioni non siano seguiti due modelli di società accettabili nell'Europa occidentale e in particolare in Italia.

Perché dico questo? Lo dico perché le Brigate rosse si mostrano, sia attraverso la loro ideologia che il loro comportamento pratico, di essere un gruppo di tipo staliniano in ritardo. Il loro ricorso ad una sentenza di condanna a morte dimostra la solo la completa estraneità di questo gruppo alla cultura europea e italiana. A chi obietta che qualunque rivoluzione e qualunque gruppo di rivoluzionari ha in qual che modo praticato la pena di morte, rispondo che questo comportamento si valuta non in sé, bensì sullo sfon-

SEGUE A PAGINA 2

Sciascia: è la fine delle Br

ROMA — Leonardo Sciascia ci ha rilasciato la seguente dichiarazione:

«Ripristinando nel nostro paese la pena di morte le Brigate rosse non solo si sono poste al di fuori di quella legittimità e legalità rivoluzionaria che follemente dicono di rappresentare ma hanno reso più difficile e angosciosa la difesa della libertà a coloro che per tutti la difendono. L'abolizione della pena di morte è stato un fatto rivoluzionario in Italia e io spero ravo che al di là della pietà le Brigate rosse se ne ricordassero almeno nel loro dirsi rivoluzionari. Non è stato così. Si apre per tutti noi un duro avvenire. Ma per loro è il principio della fine».

LEONARDO SCIASCIA

132

Météo

Nuageux sur le versant
nord des Alpes, sinon
assez ensoleillé.

18
—
2

Notre sélection TV

TV romande, 20 h. 25
«Vassa»
de Gorki

JA No 92 – Vendredi 21 avril 1978

70 ct.

Edition Dernière Heure

TRIBUNE

QUOTIDIEN
FONDÉ EN 1879

DE GENÈVE

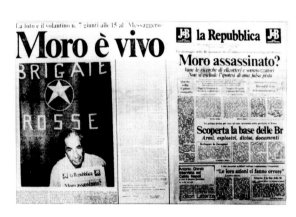

THE BULLETIN

Bend, Deschutes County, Oregon, Monday February 26, 1979 Twenty Cents No. 49

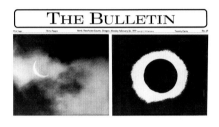

The COLUMBIAN

No. 120 Monday, Feb. 26, 1979 The Columbian 1979, Vancouver, Washington (206) 694-3391 64 Pages, 6 Sections

THE DAILY WORLD
Serving Coastal Washington

NINETEENTH YEAR, NO. 251 MONDAY, FEBRUARY 26, 1979 TWO SECTIONS—44 PAGES—15¢

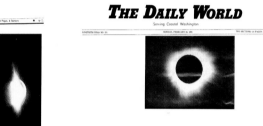

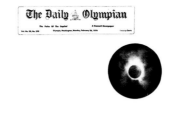

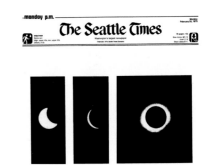

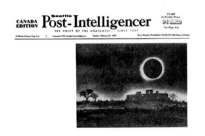

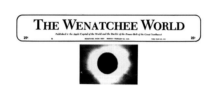

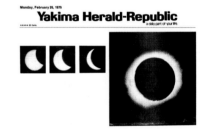

Tri-City Herald

Regional Voice of the Mid-Columbia Empire

MONDAY, FEBRUARY 26, 1979

Tri-Cities, Pasco Kennewick Richland, Washington

Walla Walla Union-Bulletin

Monday, February 26, 1979

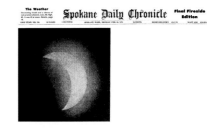

A special edition of today's
LEWISTON TRIBUNE

in celebration of the Feb. 26,
1979, total eclipse of the sun
(which most of us didn't see)

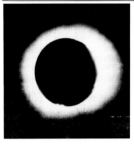

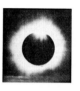

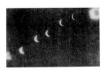

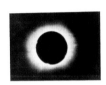

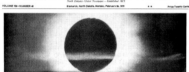

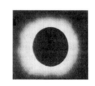

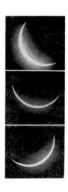

142

Grand Forks Herald

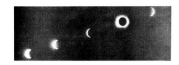

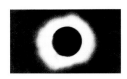

The Times-News

سنجابی:
هنوز دستگاه
استبداد
بر کشور
مسلط است
‹ صفحه ۲ ›

امام خمینی:
پیروزی هنوز کامل نیست

کیهان — چاپ دوم
تکشماره ۱۵ ریال
چهارشنبه ۲۷ دی ۱۳۵۷ - ۱۸ صفر ۱۳۹۹ - شماره ۱۰۶۱۵

اختلافات حزبی و مذهبی را کنار بگذارید

آمریکا شریک یک جرم رژیم در کشتار ملت است
‹ صفحه ۶ - ستون اول ›
بوسیله آیت‌الله‌العظمی خمینی

اموال شاه ملی اعلام شد
‹ صفحه ۲ - ستون هفتم ›

ایران، یک چشم خندان یک چشم گریان
زلزله خراسان صدها نفر را کشت

آمار تلفات زلزله:
آیت‌الله‌العظمی شیرازی: ۸۰۰ نفر
ژاندارمری قاین: ۱۵۲ نفر
خبرگزاری پارس: ۱۳۰ نفر
‹ صفحه آخر ›

عده‌ای از نمایندگان مجلس استعفا کردند
‹ صفحه ۲ ›

وزیر دادگستری استعفا کرد
‹ صفحه آخر ›

در تهران و دهها شهر ایران:
مردم، مجسمه‌ها را پائین کشیدند

وقتی لحظه سقوط میرسد

اینجا میدان توپخانه است، سیل جمعیت نیروی خود را بکار برده و حالا مجسمه سنگین پدر شاه در حالیکه سوار اسب است، به آستانه سقوط رسیده است. لحظاتی بعد شاه و اسب‌سوار فرو می‌افتند.
‹ صفحه ۵ - ستون اول ›

در طلوع آزادی جای شهدا خالی
میلیونها نفر رفتن شاه را جشن گرفتند
‹ صفحات ۳ و ۶ ›

تظاهرات اهواز به خون کشیده شد

در طغیان عده‌ای از سربازان، دهها نفر از مردم کشته و مجروح شدند
‹ صفحه ۲ ›

اما هنوز آزاد نیستیم

دیوارها یک یک فرو می‌ریزد. سقف آسمان بلند و شفاف است. درهای خانه‌ها به دشواری باز می‌شود. تمام شهرهای میهن حیات جامعه می‌رسد. سقف آسمان بلند و شفاف‌تر شده است...

(متن کامل ستون در صفحات داخلی)

از طرف جامعه روحانیت اعلام شد:
مقررات راهپیمائی جمعه

اعلامیه شماره ۲
کمیته تدارکات راهپیمائی
بسم‌الله الرحمن الرحیم

اکنون که نهضت عظیم اسلامی ما با حجم حساس فراوان...

۱ - فقط به تذکرات مأمورین انتظامی که از طرف جامعه روحانیت با آرم مشخص و متشکل‌الشکل خدمات انتظامی را بعهده گرفته‌اند توجه فرمائید.
۲ - از پخش هرگونه اعلامیه و نشریه و نیز از قبول آن خودداری فرمائید...

سلام آزادی

(متن شعر و مقاله)

... سلام آزادی
... سلام آزادی

هوشنگ امیری

سقوط بهمن باعث خاموشی شد

...

در اجتماع برشکره ساکنان غرب تهران در موسسه کیهان:
«خبرگزاری انقلاب اسلامی» باید تشکیل شود

...

اعتصاب پسندن خاموشی

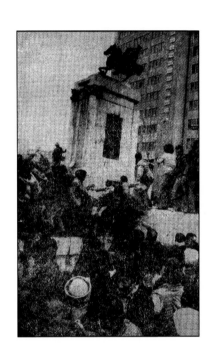

SCOTTISH DAILY
EXPRESS

No. 24,467 Saturday March 3 1979 Weather : Wintry showers 9p

UNITED
WE
STAND

SATURDAY March 3 1979

A NATION DIVIDED

Available Light

Laurie Simmons

The door to Sarah Charlesworth's studio—one large room in a modest, single-story office building on the leafy-green main street of Falls Village, Connecticut—is slightly ajar. I'm visiting for the first time since she died unexpectedly on June 25, and I'm a little rattled. I've just picked up the key from the kitchen of her unlocked house, where her hairbrush and Chanel lipstick are, as always, next to the sink in the downstairs bathroom.

Everything is peaceful and scented with summer (her favorite season) as I walk the few dozen yards past her garden and down the street to her studio. I notice the spot near the sidewalk where she set up what she affectionately called her "self-portrait scarecrow with crows" for the 2011 Falls Village scarecrow contest. Perhaps she had appreciated that her initials could also stand for Scare-Crow. My daughter and I had driven to the autumn festival under strict orders from Sarah to stuff the ballot box with votes in the "most creative" category. She had worked for days and really wanted to win. When we arrived, I spotted Sarah in the crowd bending forward and looking through a large-format camera with a black focusing cloth over her shoulders. Her blond hair hid her face, and she was in her casual weekend outfit: blue jeans, white quilted Nikes. Only, wait! It wasn't Sarah, but rather, Sarah's scarecrow—so realistic that, according to her boyfriend, the playwright and Falls Village resident Lonnie Carter, visitors stopped to ask it for directions. Sarah kept a snapshot of her prizewinning doppelgänger on her computer desktop alongside her work.

I slip into the studio and wonder why the door is open. Matthew Lange, her longtime assistant, is unpacking his cameras. I'd almost forgotten we'd agreed to meet and photograph Sarah's studio before it is dismantled. I am carrying a small light box, which I intend to swap for the big one on her worktable—we provisionally switched a few years ago. Everything looks ready for work. Matthew points out a brand-new tripod and a barely used field camera. The placement of objects that I'd always taken for granted is thrown into high relief by the knowledge that each camera, prop, and tool has been put down for the very last time. A chair here; a book there; two cutout photographs, seemingly unrelated, joined together and tacked to the wall. There were no visual accidents in Sarah Charlesworth's world.

She claimed to have wept tears of joy the day in 2004 when she officially bought her small, pristine 1830 Greek Revival house. I imagine it as one of the more emotional transfers of property, with Sarah announcing at the closing that this was her dream come true—the first house she had ever owned. For at least three months, she kept a dozen or so white paint chips taped to the walls, trying to decide which room needed to be which shade. As fanatical about the path of the sun as was Monet, Sarah planned a color scheme for each space that took into consideration the time of day and the direction from which light would rake across the walls. I found her

deliberations obsessive and told her to just get the job done, but afterward I relied on her for advice about all things white. Master printers at photo labs have told me that Sarah's fixation on the "right white" was "memorable," and hers were among the most challenging artist projects they had undertaken. In her 1981 series "Tabula Rasa," Sarah made white-on-white silkscreen prints with an image that is difficult to identify. It is an enlargement of Joseph Nicéphore Niépce's *La Table Servie* (ca. 1829)—generally believed to be one of the first permanently recorded photographic images.

The picture window in Sarah's Connecticut studio is fifty inches square and covered with a piece of translucent vellum taped around the edges. Her view camera and black cloth are placed squarely in front of it. This is where her last series were shot, including "Work in Progress" (2009) and "Available Light" (2012). The works in "Available Light" are all shimmering turquoise and white, with glowing glass and metal objects floating in aqueous reflections. Somehow, they feel both cottony and watery and, in my mind, spiritual enough to presage an untimely death.

Standing in her studio, I think about her work as a journey now completed, one that starts with the whiteness of "Tabula Rasa," winds and snakes though intense colors and myriad subjects, from trees to toile to Gerrit Rietveld's *Red Blue Chair* (ca. 1923), and comes to an end with the pale luminosity of "Available Light." This is my personal idea of her trajectory, but any account of Sarah's work, no matter how subjective, wouldn't be complete without mentioning such formidable series as her early "Stills" (1980) and "Modern History" (1977–79), the group of complex, multipart newspaper pieces that follow consecutive days of front-page news headlines, with all type deleted. I use the words *winds* and *snakes* to describe her work because making it was a torturous process for Sarah, as she freely admitted. What felt to me like beautiful and intuitive pictures were actually researched, scanned, investigated, and X-rayed within an inch of their photographic lives, as Sarah searched for their meaning. Only when a work could withstand every imaginable critique and answer every question that Sarah could ask could it stand on its own, fortress-like and finished. I was never invited to see works in progress and rarely saw any before they entered the gallery space—odd, given our close friendship. But that didn't mean there weren't endless talks between us about what it all meant, about the perils of keeping the message of the photographic medium alive, and about how many times Sarah would go around the world in eighty ways to prove the camera a viable tool for art-making.

I don't know what I expected to find in Sarah's studio—maybe a story with a beginning, a middle, and an end. But an artist's work is never done. It is not a family business that can be left to the firstborn. Can an artist ever die without work in progress?

I lean over to pick up the light box and remove a piece of museum board that covers its surface. I switch on the light. There are three pairs of chromes and two triptychs. Although the dominant color in one pair of images is a vivid ultramarine, the star of the show is the color green, which is bright, blinding, a threat to the green vegetables and flowers growing out of control in Sarah's garden down the street. The pictures look like what you'd see on a lazy summer day if you flopped down in the grass and looked straight up through the trees—layers of spring green, summer green, asparagus green, avocado, chartreuse, emerald, forest, hunter, jade, jungle, kelly, lime, olive, pine, and

viridian, all making lacy patterns in front of the sky. And, most surprising of all, there is a pure green parrot, floating on a green background.

I am stunned, excited, and ultimately sad. I will not hear Sarah's stories about how these pictures were made, nor will I ever know if they are done. I ask Matt as many questions as I can, hoping he can fill in the blanks. He tells me that Sarah always wanted to photograph a green parrot against a green wall and that when she saw a woman walking on Ninth Avenue in Manhattan with a parrot on her shoulder, she decided the time was right. Sarah invited the parrot lady to her New York studio so she could shoot a portrait of the bird. When Sarah offered her a fee, the woman asked for a check made out to her first name only. Sarah was clearly having some fun with her work.

Matt also mentioned that Sarah had been looking at a lot of 1920s and '30s abstraction, especially De Stijl and the Bauhaus. She was thinking about visual harmony as it appears in art, as opposed to its appearance in nature. Hence the chromes of monochromatic stripes and images with allover patterns of leaves and flowers. I bend down, pick up a piece of masking tape from the floor, and see that there are bits of fern stuck to it. Aha—Sarah had taped ferns to the vellum on the window in order to make a pattern that was not dissimilar to the banana-leaf wallpaper in the coffee shop at the Beverly Hills Hotel, which we'd visited together. (She would have detested that comparison.)

Sarah was old-school. Not old-school as in sneakers, music, or slang—those distinctions were lost on her. She was an old-school friend—email, texting, and social media were no substitute for face time. Cindy Sherman had introduced me to her new friend Sarah in 1982. We saw her as a woman with a past. Some of us had started exhibiting work a few years earlier, but Sarah had already been a Marxist and a member of Art & Language and had founded the magazine *The Fox* with Joseph Kosuth. I perceived her as a "real" Conceptual artist, and at the same time it seemed as if she wanted to start over. Perhaps she felt as we did, that as women we might commandeer the camera in a new way—not as photographers, but as artists using new technology, thus extricating ourselves from the weighty and male-dominated history of painting. From the moment we met, she wouldn't let me *not* be her friend and insisted on being part of a woman-artist "gang." With Gretchen Bender, Nancy Dwyer, Barbara Kruger, Louise Lawler, Sherrie Levine, and Sherman, there were informal gatherings and shows where we felt, at least loosely, like we were part of something new (something that in my mind was never precisely congruent with "Pictures," a label I've always treated with caution). Petty envies, self-indulgent comparisons, and art-career competitions were not part of her frame of reference; she didn't know how to feel those things.

Sarah was also an old-school mother—she insisted on a bath and a home-cooked meal every night for her children, Lucy and Nick. Most importantly, and above all else, she was an old-school artist. For her, maintaining artistic integrity and getting into the studio against all odds were all it took to call oneself an artist. Sarah was proud of her teaching, proud of her work, and proud to invite people for studio visits that lasted all day and in which she painstakingly and insistently explained the history of her images, as well as the history of photography as she saw it. "Sarah," I would say when she would call me to recount the details of these marathon meetings, "that was not a studio visit—it was a kidnapping." She would laugh and continue to describe the day, which invariably included a picnic basket and a tour of her favorite local

destinations. When she first found a studio in Williamsburg, she made me visit at day's end, just so we could watch the sunset from her window. If you were lucky enough to be invited over, you probably still remember that view.

With uncommon precision, Sarah scrutinized the photographic image from each and every angle, mining its history, context, media value, symbolic resonance, materiality, and—most poignantly—its self-creation as a phenomenon of focused and available light. She had a methodical manner and an analytical temperament, but somehow never lost her naïve wonder at the magic and multiplicity of the image. Despite her in-depth readings and technical expertise, her vast knowledge never diminished her fundamental awe of the endless potential of the photographic image at this specific moment in history. It turns out that Sarah's last images were not, as I had expected, about playing with themes of vanishing and disappearance (though in earlier series, she took on the persona of the magician engaging in visual sleights of hand), but about the promise of spring, the redolence of summer, and the pictorial mind-set of having all the time in the world.

Reprinted with permission. © *Artforum*, November 2013, "Sarah Charlesworth," by Laurie Simmons.

Continuum

Sara VanDerBeek

> The range of expression of a healthy, whole human being should be challenged to encompass everything from the political, to the sensual, to the intellectual, even to an appreciation of abstract beauty or form.
>
> —Sarah Charlesworth in an interview with David Deitcher
> for *Afterimage*, 1984

Two years after her sudden death, Sarah Charlesworth feels ever more present in her absence. Her work and its influence, her writing, and her voice continue to resonate. In the colors, subjects, and surfaces of her photographs she is present. Her hand, her intelligence, and her entire being emanate from her work.

Sarah collaged Conceptualism, popular media, archival activities, educational practices, motherhood, friendship, humor, and charm into an intensely considered and expertly crafted image-language. From her use of found imagery to her later use of natural light, she was continuously pushing the ways and means of creating her photographs.

Central to the dialogues around the new practices that were arising out of the New York art world in the 1980s, Charlesworth was a formidable figure. Yet, like Francis Picabia, whom she references in several of her works, she was both of and apart from the movement she was associated with: the Pictures Generation. Sarah—perhaps more so than many of her peers—collapsed image, object, time, and form into both singular and multipart works that challenged conventional definitions of the photographic.

Seeing "Objects of Desire" (1983–88) all together recently at Maccarone Gallery, New York, was a transcendent experience. Its strength, prescience, and conceptual resolve were profoundly moving. Visiting that show was like entering a skewed "Book of Dreams" populated with archetypes of the unconscious rendered deftly via 1980s source material. Like much of her work, this series effectively balanced the metaphysical, intuitive, and critical all at once. *Fear of Nothing* (1988) with its black void, horror vacui mask, and primary shapes is my favorite. It is a divination mirror, transcending the present to look back to the early foundations of the contemporary psyche and on to a new world of image-making in keeping with the shifting media culture of our time.

At her memorial, recollections of a striking, tough blonde wearing white gloves surprised me. I wondered at this detail when I heard it. She was always well dressed and composed, but this image seemed fanciful and outside my sense of her. I then learned of why the gloves were needed. Because Sarah worked constantly in the darkroom, her hands were wrecked by the chemistry. I liked this as a symbol of Sarah's approach to being an artist, a pragmatic and thoughtful solution yet not without its sense of theatrical flourish.

This sartorial gesture also spoke to her way of being and engaging with the world. Sarah, as I mentioned before, seemed very much her own entity and was interested more in where an idea may lead than in hewing to any one particular known style. She came to rest in a place of her own creation. Images of her studio appeared in her last show, "Available Light," at Susan Inglett Gallery, New York, in 2012. The works unfold slowly, revealing through discreet and subtle forms a guide to her practice and life as a whole. They are resonant with the deep thought and consideration that she gave to everything.

Her process and practice encompassed all manner of creation and capture, yet both were consistently tied to her adept use of photography. Her technical proficiency was impressive, so much so that her use of the camera was the last thing you thought about when viewing one of her images. Your focus went to what it was conveying, where it took you as you moved among its layers—pushing forward deeper and farther then you had perhaps gone before with a photograph.

The white gloves of earlier days appeared later in *Trial by Fire* (1992–93) from Sarah's "Natural Magic" (1992–93) series—the first series for which she captured her own imagery. This image of her own gloved hands alight—with its mixture of alchemy, bravura, and experimentation—is a perfect analogy for the way she approached a new idea. Sarah was continually experimenting and editing throughout the creation of a series. I greatly respected her for that. She spoke of throwing ideas and images up against the blank white wall of the studio and shooting and reshooting an image until it was resolved. "Natural Magic" recalls Giovanni Battista della Porta's *Magiae Naturalis* (1558) and at first, as a body of work, it seems to value the myth-making history of her medium. Yet the apparent staging of the stunt reveals a practitioner simultaneously examining and reveling in the magic of photography.

Trial by Fire, like all of her titles, is impeccable. Another title—"Stills"—gets at an elemental concern of photographic capture and its meaning with an economy of language that mirrors the succinct realization of her images. Sarah spoke once about her process of titling this evocative body of work and, in doing so, conveyed a keen understanding of language—both verbal and visual—that extends throughout all aspects of her practice: "My decision to call [this] collection of images 'Stills' has very much to do with my conception of a still photograph as a fragment of a continuum."[1] Sarah's interviews, essays, public presentations, and intimate conversations were generous and meticulous in their construction—and their impact.

I continue to feel Sarah's absence and her presence. Equally I wish I could reiterate to her in person how formative her work and her practice have been to my own. But I hope in this short space to have conveyed the significance that Sarah's work and being have had in my life and the lives of my peers. We will continue to look to her as a mentor, as an artist to emulate, and as a strong and powerful woman who was engaged in many causes, most critically for that of equality and respect for all humans and for images of all kinds.

1. Sarah Charlesworth quoted in "Dialogue: Sarah Charlesworth with Betsy Sussler," *Cover* magazine, Spring/Summer 1980, 23, quoted in Susan Fischer Sterling "In-Photography: The Art of Sarah Charlesworth," in *Sarah Charlesworth: A Retrospective* (Santa Fe, SITE Santa Fe, 1997), 77.

Still

Cindy Sherman

I met Sarah in the fall of '82. Joseph Kosuth, whom I'd just met, insisted I get in touch with her. I'd seen her around before, but she scared me—I found her unapproachable and intimidating with her ever-present white gloves and cigarette holder. Once, at an after-party for a Troy Brauntuch show at Metro Pictures, I told Troy that I was sorry to miss the opening but that I loved the show (I'd seen it earlier in the day). Sarah challenged me, as if catching me in a fib, and even though I wasn't lying, I felt guilty.

Even after we became friends, there was still something intimidating about how damn smart she was—the way she could discuss anyone's art or theories, rise to any debate, challenge any statement. I was just starting to come into my own as an artist, but, intellectually, she seemed already fully formed and hugely confident.

The first work I'd seen of hers was the "Stills" series (1980), in reproduction somewhere. I still cannot stop staring at these works, as if trying to glean something from the identity of the people, something about what they're thinking at that moment, what it's like to know you're about to die within seconds. Is there relief? Regret? Fear? How long did they stand up there on top of the building before they jumped? How old are they, and what was going on in their lives to make them do this?

Then I think of the person taking the photo: how did they happen to be there? There was probably a crowd of people watching this individual standing on the ledge, photographers with cameras ready—such a bleak and grim assignment. And what was the story accompanying the photograph? How or why did it get into the paper, and what led Sarah to discover it?

The series is seemingly so different from her subsequent work, but similar because she was choosing images of isolated, powerful moments the way she would later isolate and recombine powerful symbolic references to recontextualize them.

I think it was important to Sarah for her work to be sublime and exquisitely beautiful: the lushness of the color, the surface of the print itself, the frame—all very specific aesthetic decisions that enhanced each piece. The works transcended mere Cibachromes and referred to the act of seeing, from the mechanics of observation to the ephemeral illusions that are impossible to capture in a photograph.

I will miss how she would've continued this exploration, especially in the current digital and photo-obsessed environment in which we find ourselves.

Sarah Charlesworth, Rome, 1989. Photo: Cindy Sherman

Checklist

April 19, 20, 21, 1978, from the "Modern History" series, 1978 [pp. 131–33]
Three black-and-white prints reproduced at the same size as the original newspapers
Dimensions variable; approximately 22 x 16 in (55.9 x 40.6 cm) each
Courtesy the Estate of Sarah Charlesworth and Maccarone Gallery, New York

Arc of Total Eclipse, February 26, 1979, from the "Modern History" series, 1979 [pp. 134–43]
Twenty-nine black-and-white prints reproduced at the same size as the original newspapers
Dimensions variable; approximately 22 x 16 in (55.9 x 40.6 cm) each
Whitney Museum of American Art, New York
Purchase, with funds from the Photography Committee 94.60a–cc

Reading Persian, from the "Modern History" series, 1979 [pp. 144–45]
Two black-and-white prints reproduced at the same size as the original newspapers
23 x 16 in (58.4 x 40.6 cm) each
Collection Jay Gorney and Tom Heman

United We Stand / A Nation Divided, from the "Modern History" series, 1979 (released 2003) [pp. 146–47]
Two black-and-white prints reproduced at the same size as the original newspapers
15¾ x 12½ in (40 x 31.8 cm) each
Courtesy the Estate of Sarah Charlesworth and Maccarone Gallery, New York

Dar Robinson, Toronto, from the "Stills" series, 1980, printed in 2012 [p. 50]
Gelatin silver print
78 x 42 in (198.1 x 106.7 cm)
The Art Institute of Chicago, gift of Thea Berggren, 2012.545

Jerry Hollins, Chicago Federal Courthouse, from the "Stills" series, 1980, printed in 2012 [p. 54]
Gelatin silver print
78 x 42 in (198.1 x 106.7 cm)
The Art Institute of Chicago, promised gift of Liz and Eric Lefkofsky, FLN 171.2012

Patricia Cawlings, Los Angeles, from the "Stills" series, 1980, printed in 2012 [p. 52]
Gelatin silver print
78 x 42 in (198.1 x 106.7 cm)
The Art Institute of Chicago, Krueck Foundation and Photography Gala funds, 2013.129

Thomas Brooks Simmons, Bunker Hill Tower, Los Angeles, from the "Stills" series, 1980, printed in 2012 [p. 44]
Gelatin silver print
78 x 42 in (198.1 x 106.7 cm)
The Art Institute of Chicago, promised gift of Liz and Eric Lefkofsky, FLN 175.2012

Unidentified Man, Ankara, Turkey, from the "Stills" series, 1980, printed in 2012 [p. 46]
Gelatin silver print
78 x 42 in (198.1 x 106.7 cm)
The Art Institute of Chicago, promised gift of Liz and Eric Lefkofsky, FLN 174.2012

Unidentified Man, Corpus Christi, Texas, from the "Stills" series, 1980, printed in 2012 [p. 49]
Gelatin silver print
78 x 42 in (198.1 x 106.7 cm)
The Art Institute of Chicago, restricted gift of Constance R. Caplan, 2013.127

Unidentified Man, Ontani Hotel, Los Angeles, from the "Stills" series, 1980, printed in 2012 [p. 56]
Gelatin silver print
78 x 42 in (198.1 x 106.7 cm)
The Art Institute of Chicago, promised gift of Liz and Eric Lefkofsky, FLN 169.2012

Unidentified Man, Unidentified Location, from the "Stills" series, 1980, printed in 2012 [p. 51]
Gelatin silver print
78 x 42 in (198.1 x 106.7 cm)
The Art Institute of Chicago, promised gift of Liz and Eric Lefkofsky, FLN 172.2012

Unidentified Man, Unidentified Location (#2), from the "Stills" series, 1980, printed in 2012 [p. 45]
Gelatin silver print
78 x 42 in (198.1 x 106.7 cm)
The Art Institute of Chicago, restricted gift of Constance R. Caplan, 2013.125

Unidentified Man, Unidentified Location (#3), from the "Stills" series, 1980, printed in 2012 [p. 48]
Gelatin silver print
78 x 42 in (198.1 x 106.7 cm)
The Art Institute of Chicago, restricted gift of Constance R. Caplan, 2013.128

Unidentified Woman, Genessee Hotel, from the "Stills" series, 1980, printed in 2012 [p. 53]
Gelatin silver print
78 x 42 in (198.1 x 106.7 cm)
The Art Institute of Chicago, promised gift of Liz and Eric Lefkofsky, FLN 170.2012

Unidentified Woman, Hotel Corona de Aragon, Madrid, from the "Stills" series, 1980, printed in 2012 [p. 43]
Gelatin silver print
78 x 42 in (198.1 x 106.7 cm)
The Art Institute of Chicago, promised gift of Liz and Eric Lefkofsky, FLN 173.2012

Unidentified Woman (Vera Atwool, Trinity Towers, Louisville, KY), from the "Stills" series, 1980, printed in 2012 [p. 55]
Gelatin silver print
78 x 42 in (198.1 x 106.7 cm)
The Art Institute of Chicago, Krueck Foundation and Photography Gala funds, 2013.130

Vivienne Revere, New York, from the "Stills" series, 1980, printed in 2012 [p. 47]
Gelatin silver print
78 x 42 in (198.1 x 106.7 cm)
The Art Institute of Chicago, Photography Gala Fund, 2013.126

Black Mask, from the "Objects of Desire" series, 1983 [p. 61]
Cibachrome print with lacquered wood frame
42 x 32 in (106.7 x 81.3 cm)
Courtesy the Estate of Sarah Charlesworth and Maccarone Gallery, New York

Red Mask, from the "Objects of Desire" series, 1983 [p. 60]
Cibachrome print with lacquered wood frame
42 x 32 in (106.7 x 81.3 cm)
Courtesy the Estate of Sarah Charlesworth and Maccarone Gallery, New York

Harness, from the "Objects of Desire" series, 1983–84 [p. 59]
Cibachrome print with lacquered wood frame
42 x 32 in (106.7 x 81.3 cm)
Courtesy the Estate of Sarah Charlesworth and Maccarone Gallery, New York

Figures, from the "Objects of Desire" series, 1983–84 [pp. 62–63]
Two Cibachrome prints with lacquered wood frames
Diptych; 42 x 62 in (106.7 x 157.5 cm)
Courtesy the Estate of Sarah Charlesworth and Maccarone Gallery, New York

Bird Woman, from the "Objects of Desire" series, 1986 [p. 66]
Cibachrome print with lacquered wood frame
42 x 32 in (106.7 x 81.3 cm)
Courtesy the Estate of Sarah Charlesworth and Maccarone Gallery, New York

Bowl and Column, from the "Objects of Desire" series, 1986 [pp. 80–81]
Two Cibachrome prints with lacquered wood frames
Diptych; 42 x 32 in (106.7 x 81.3 cm) each
Courtesy the Estate of Sarah Charlesworth and Maccarone Gallery, New York

Bull, from the "Objects of Desire" series, 1986 [p. 75]
Cibachrome print with lacquered wood frame
42 x 32 in (106.7 x 81.3 cm)
Private collection, New York

Goat, from the "Objects of Desire" series, 1985 [p. 65]
Cibachrome print with lacquered wood frame
42 x 32 in (106.7 x 81.3 cm)
Collection B.Z. and Michael Schwartz, New York

Gold, from the "Objects of Desire" series, 1986 [p. 70]
Cibachrome print with lacquered wood frame
42 x 32 in (106.7 x 81.3 cm)
Collection Howard Bates Johnson
Courtesy Richard Milazzo

Lotus Bowl, from the "Objects of Desire" series, 1986 [p. 73]
Cibachrome print with lacquered wood frame
42 x 32 in (106.7 x 81.3 cm)
Collection Richard Milazzo and Joy L. Glass, New York

Madonna, from the "Objects of Desire" series, 1986 [p. 67]
Cibachrome print with lacquered wood frame
42 x 32 in (106.7 x 81.3 cm)
Courtesy the Estate of Sarah Charlesworth and Maccarone Gallery, New York

Virgin, from the "Objects of Desire" series, 1986 [p. 71]
Cibachrome print with lacquered wood frame
42 x 32 in (106.7 x 81.3 cm)
Collection Nicole Klagsbrun

Buddha of Immeasurable Light, from the "Objects of Desire" series, 1987 [pp. 76–77]
Two Cibachrome prints with lacquered wood frames
Diptych; 42 x 62 in (106.7 x 157.5 cm)
The Museum of Modern Art, New York
Carol and David Appel Family Fund

Maps, from the "Objects of Desire" series, 1987 [p. 83]
Two Cibachrome prints with lacquered wood frames
Diptych; 42 x 62 in (106.7 x 157.5 cm)
Collection Christopher and Felicitas Brant

Natural History, from the "Objects of Desire" series, 1987 [p. 79]
Three Cibachrome prints with lacquered wood frames
Triptych; 42 x 62 in (106.7 x 157.5 cm)
Collection Ilene Kurtz-Kretzschmar and Ingo Kretzschmar

Fear of Nothing, from the "Objects of Desire" series, 1988 [pp. 68–69]
Two Cibachrome prints with lacquered wood frames
Diptych; 32 x 32 in (81.3 x 81.3 cm) each
Collection Dr. Dana Beth Ardi

Transfiguration, from the "Renaissance Paintings" series, 1991 [p. 88]
Cibachrome print with lacquered wood frame
59¾ x 45¾ in (151.8 x 116.2 cm)
Courtesy the Estate of Sarah Charlesworth and Maccarone Gallery, New York

Transfixion, from the "Renaissance Paintings" series, 1991 [p. 89]
Cibachrome print with lacquered wood frame
59¾ x 45¾ in (151.8 x 116.2 cm)
Courtesy the Estate of Sarah Charlesworth and Maccarone Gallery, New York

Vision of a Young Man, from the "Renaissance Paintings" series, 1991 [p. 87]
Cibachrome print with lacquered wood frame
59¾ x 45¾ in (151.8 x 116.2 cm)
Courtesy the Estate of Sarah Charlesworth and Maccarone Gallery, New York

Doubleworld, from the "Doubleworld" series, 1995 [p. 94]
Cibachrome print with mahogany frame
51 x 41 in (129.5 x 104.1 cm)
Courtesy the Estate of Sarah Charlesworth and Maccarone Gallery, New York

Still Life with Camera, from the "Doubleworld" series, 1995 [pp. 92–93]
Two Cibachrome prints with mahogany frames
Diptych; 51 x 81 in (129.5 x 205.7 cm)
Montclair Art Museum; Gift of Patricia A. Bell, 2004.2.2a-b

Untitled (Voyeur), from the "Doubleworld" series, 1995 [p. 95]
Cibachrome print with mahogany frame
51 x 41 in (129.5 x 104.1 cm)
Collection Jennifer and David Stockman

Vanitas, from the "Doubleworld" series, 1995 [p. 91]
Cibachrome print with mahogany frame
51 x 41 in (129.5 x 104.1 cm)
Courtesy the Estate of Sarah Charlesworth and Maccarone Gallery, New York

Bough, from the "0+1" series, 2000 [p. 113]
Fujiflex print with lacquered wood frame
44 x 34 in (111.8 x 86.4 cm)
Collection Barbara and Irvin Goldman

Monkey, from the "0+1" series, 2000 [p. 114]
Fujiflex print with lacquered wood frame
44 x 34 in (111.8 x 86.4 cm)
Collection Judith Hudson, New York

Screen, from the "0+1" series, 2000 [p. 115]
Fujiflex print with lacquered wood frame
44 x 34 in (111.8 x 86.4 cm)
Collection Melva Bucksbaum and Raymond Learsy

Seated Buddha, from the "0+1" series, 2000 [p. 117]
Fujiflex print with lacquered wood frame
44 x 34 in (111.8 x 86.4 cm)
Collection Richard Edwards, Aspen

Skull, from the "0+1" series, 2000 [p. 116]
Fujiflex print with lacquered wood frame
44 x 34 in (111.8 x 86.4 cm)
Courtesy the Estate of Sarah Charlesworth and Maccarone Gallery, New York

Candle, from the "Neverland" series, 2002 [p. 119]
Cibachrome print with lacquered wood frame
41½ x 31½ in (105.4 x 80 cm)
Collection Dr. Dana Beth Ardi

Figure Drawings, 1988/2008 [pp. 110–11]
Installation of forty Fuji Crystal Archive prints, mounted and laminated, with lacquered wood frames
9½ x 12 in (24.1 x 30.5 cm) each
Courtesy the Estate of Sarah Charlesworth and Maccarone Gallery, New York

Camera Work, from the "Work in Progress" series, 2009 [pp. 2–3, 121]
Two Fuji Crystal Archive prints, mounted and laminated, with lacquered wood frames
Diptych; 52 x 77½ in (132.1 x 196.9 cm)
Collection B.Z. and Michael Schwartz, New York

Carnival Ball, from the "Available Light" series, 2012 [p. 124]
Fuji Crystal Archive print with lacquered wood frame
41 x 32 in (104.1 x 81.3 cm)
Courtesy the Estate of Sarah Charlesworth and Maccarone Gallery, New York

Crystal Ball, from the "Available Light" series, 2012 [p. 123]
Fuji Crystal Archive print with lacquered wood frame
32 x 32 in (81.3 x 81.3 cm)
Courtesy the Estate of Sarah Charlesworth and Maccarone Gallery, New York

Half Bowl, from the "Available Light" series, 2012 [p. 125]
Fuji Crystal Archive print with lacquered wood frame
41 x 32 in (104.1 x 81.3 cm)
Courtesy the Estate of Sarah Charlesworth and Maccarone Gallery, New York

Shiva Light, from the "Available Light" series, 2012 [pp. 126–27]
Two Fuji Crystal Archive prints with lacquered wood frames
Diptych; 41 x 63 in (104.1 x 160 cm)
Collection Leigh and Reggie Smith

Studio Wall, from the "Available Light" series, 2012 [p. 129]
Fuji Crystal Archive print with lacquered wood frame
41 x 32 in (104.1 x 81.3 cm)
Courtesy the Estate of Sarah Charlesworth and Maccarone Gallery, New York

Selected Biography

B. 1947 East Orange, NJ; D. 2013, Falls Village, CT

EDUCATION

1969
BA, Barnard College, New York

SOLO EXHIBITIONS

2015
"Sarah Charlesworth: Doubleworld," New
 Museum, New York

2014
"Stills," Art Institute of Chicago
"Objects of Desire: 1983–1988," Maccarone
 Gallery, New York

2012–13
"Available Light," Susan Inglett Gallery, New York;
 Baldwin Gallery, Aspen, CO

2009–10
"Work in Progress," Susan Inglett Gallery, New
 York; Baldwin Gallery, Aspen, CO

2009
"Selected Work 1978–2009," Galerie Tanit,
 Munich

2006–07
"Concrete Color," Margo Leavin Gallery, Los
 Angeles; Baldwin Gallery, Aspen, CO

2005
"Simple Text," Baldwin Gallery, Aspen, CO

2000–03
"0 + 1," Gorney Bravin + Lee, New York; Margo
 Leavin Gallery, Los Angeles; Baldwin Gallery,
 Aspen, CO

2002
"Neverland," Gorney Bravin + Lee, New York

1998
"Doubleworld," Fay Gold Gallery, Atlanta, GA
"Sarah Charlesworth," Camera Obscura, San
 Casciano dei Bagni, Italy

1997–99
"Sarah Charlesworth, A Retrospective,"
 SITE Santa Fe, NM [traveling: Museum of
 Contemporary Art, San Diego, CA; National
 Museum of Women in the Arts, Washington,
 DC; Cleveland Center for Contemporary Art,
 OH; Rose Art Museum, Brandeis University,
 Waltham, MA]

1995–96
"Doubleworld," Jay Gorney Modern Art, New York;
 S.L. Simpson Gallery, Toronto; Margo Leavin
 Gallery, Los Angeles

1993
"Natural Magic," S.L. Simpson Gallery, Toronto;
 Galerie Rizzo, Paris; Jay Gorney Modern Art,
 New York

1992
"Renaissance Paintings" (with Judith Barry), Rena
 Bransten Gallery, San Francisco
"Objects of Desire," Galerie Carola Mosch, Berlin
"Herald Tribune: November, 1977" and "Herald
 Tribune: January 18–February 28, 1991,"
 Queens Museum of Art, New York

1991
"Renaissance Paintings," Paley Wright Gallery,
 London; Galerie Xavier Hufkens, Brussels
"Renaissance Paintings & Drawings," Jay Gorney
 Modern Art, New York

1989–90
"Academy of Secrets," Jay Gorney Modern Art,
 New York; S.L. Simpson Gallery, Toronto

1987–89
"Objects of Desire," Tyler Gallery, Tyler School of
 Art, Temple University, Elkins Park, PA; Galerie
 Hufkens Noirhomme, Brussels; Interim Art,
 London

1987
"Objects of Desire IV," Margo Leavin Gallery, Los
 Angeles; International With Monument, New
 York

1986
"Objects of Desire III," International With
 Monument, New York; S.L. Simpson Gallery,
 Toronto

1985
"Objects of Desire II," International With
 Monument, New York

1984
"Modern History," California Museum of
 Photography, Riverside
"Objects of Desire I, In-Photography, Tabula
 Rasa," Clocktower Gallery, New York

1982–84
"In-Photography," Tony Shafrazi Gallery, New York;
 CEPA Gallery, Buffalo, NY; Light Work,
 Syracuse, NY

1982
"Tabula Rasa," Larry Gagosian, New York

1981
"The White Lady," Galerie Micheline Szwajcer,
 Antwerp, Belgium

1980
"Stills," Tony Shafrazi Gallery, New York

1979
"Modern History: April 21, 1978, and Arc of Total
 Eclipse, February 26, 1979," New 57 Gallery,
 Edinburgh

1978–79
"Modern History: April 21, 1978," Pio Monte
 Gallery, Rome; Centre d'Art Contemporain
 Genève; Galerie Eric Fabre, Paris; New 57
 Gallery, Edinburgh

1978
"Modern History: Herald Tribune, September,
 1977," C Space, New York; Centre d'Art
 Contemporain Genève
"Modern History: April 20, 1978," Zona, Florence

1977
"14 Days," MTL Gallery, Brussels

SELECTED GROUP EXHIBITIONS

2015
"Looking Back / The 9th White Columns Annual,"
 White Columns, New York

2014
"Whitney Biennial 2014," Whitney Museum of
 American Art, New York

2012
"Photography from the collection of the Art
 Institute of Chicago," Art Institute of Chicago
"Shock of the News," National Gallery of Art,
 Washington, DC
"Color Pictures," Fort Worth Contemporary Arts,
 TX

2011
"Sun Works," Berkeley Art Museum and Pacific
 Film Archive, CA
"September 11," MoMA P.S.1, Long Island City, NY
"The Deconstructive Impulse: Women Artists
 Reconfigure the Signs of Power, 1973–1992,"
 Contemporary Arts Museum, Houston, TX
 [traveling: Neuberger Museum of Art, Purchase,
 NY; Nasher Museum of Art, Durham, NC]
"Another Story: Photography from the Moderna
 Museet Collection," Moderna Museet,
 Stockholm
"Signs of a Struggle: Photography in the Wake of
 Postmodernism," Victoria and Albert Museum,
 London

2010–11
"Singular Visions," Whitney Museum of American
 Art, New York
"The Last Newspaper," New Museum, New York

2010
"Haunted: Contemporary Photography/Video/
 Performance," Solomon R. Guggenheim

Museum, New York [traveling: Guggenheim Museum Bilbao, Spain]

"Rhetorik der Bilder (Rhetoric of Images)," Museum für Photographie Braunschweig, Germany

"Conceptual Photography," Musée d'Art Moderne et d'Art Contemporain, Nice, France

"Abstract Resistance," Walker Art Center, Minneapolis, MN

"Press Art: The Collection of Annette and Peter Nobel," Kunstmuseum St. Gallen, Switzerland [traveling: Museum der Moderne, Salzburg, Germany]

2009

"Images et (Re)Presentations," Le Magasin, Centre National d'Art Contemporain, Grenoble, France

"The Pictures Generation, 1974–1984," Metropolitan Museum of Art, New York

"Better History," American Standard Gallery, New York

"Printed Matter," Fotomuseum Winterthur, Switzerland

"A Twilight Art," Harris Lieberman, New York

2008

"Photography on Photography: Reflections on the Medium since 1960," Metropolitan Museum of Art, New York

"The Human Face is a Monument," Guild & Greyshkul, New York

"Jedermann Collection – Set 5 from the Fotomuseum Winterthur Collection," Fotomuseum Winterthur, Switzerland

2007

"RoseArt: Works from the Permanent Collection," Rose Art Museum, Brandeis University, Waltham, MA

2006

"Belief and Doubt," Aspen Art Museum, CO

"Recent Acquisitions in Contemporary Photography," Metropolitan Museum of Art, New York

"The Downtown Show: The New York Art Scene, 1974–1984," Grey Art Gallery, New York; [traveling: Andy Warhol Museum, Pittsburgh, PA]

2005

"For Presentation and Display: Some Art of the '80s," Princeton University Art Museum, NJ

"Covering the Real," Kunstmuseum Basel

"Contemporary Photography in the Age of Mechanical Reproduction," New Britain Museum of American Art, CT

"East Village USA," New Museum, New York

2004

"Visions from America," Wexner Center for the Arts, Columbus, OH

"Speaking with Hands, Photographs from the Buhl Collection," Solomon R. Guggenheim Museum, New York [traveling: Guggenheim Museum Bilbao, Spain]

"The Last Picture Show: Artists Using Photography 1960–1982," Walker Art Center, Minneapolis, MN [traveling: Hammer Museum, Los Angeles; Museo de Arte Contemporánea de Vigo, Spain; Fotomuseum Winterthur, Switzerland; Miami Art Central, FL]

2003

"Sarah Charlesworth, Louise Lawler, and Laurie Simmons: Designs For Living," Margo Leavin Gallery, Los Angeles

"Constructed Realities: Contemporary Photography," Orlando Museum of Art, FL

"Off the Press: Recontextualizing the Newspaper in Contemporary Art," Southeast Museum of Photography, Daytona Beach, FL

2002

"Visions from America: Photographs from the Whitney Museum of American Art, 1940–2001," Whitney Museum of American Art, New York

"Still Photography," Frances Young Tang Teaching Museum and Art Gallery, Saratoga Springs, NY

"Feminism and Art: Selections from the Permanent Collection," National Museum of Women in the Arts, Washington DC

"Seeing Things: Photographing Objects, 1850–2001," Victoria and Albert Museum, London

2001

"Tele[visions]," Kunsthalle Wien, Vienna

2000

"Photography Now," Contemporary Arts Center, New Orleans, LA

"20/20 Twentieth Century Photography Acquisitions," Museum of Fine Arts, Santa Fe, NM

1999

"The American Century: Art & Culture 1950–2000," Whitney Museum of American Art, New York

"Double Vision," Nexus Contemporary Art Center, Atlanta, GA

1998

"Civic Art In Sienese Villages: Three Contemporary Artists Create Public Works," Museo Santa Maria della Scala, Siena, Italy

"From The Heart: The Power of Photography—A Collector's Choice," Art Museum of South Texas, Corpus Christi

1997

"Eye of the Beholder: Photographs from the Avon Collection," International Center of Photography, New York

"Identity Crisis: Self Portraiture at the End of the Century," Milwaukee Art Museum, WI

"Table Tops: Morandi's Still Lifes to Mapplethorpe's Flower Studies," California Center for the Arts, Escondido

1996

"Making Pictures: Women and Photography, 1975–Now," Nicole Klagsbrun Gallery, New York

"Just Past: The Contemporary in MOCA's Permanent Collection, 1975–96," Museum of Contemporary Art, Los Angeles

"Some Grids," Los Angeles County Museum of Art

"Model Home," Clocktower Gallery, Institute of Contemporary Art, New York

1994

"Rudiments d'un Musée Possible," Musée d'Art Moderne et Contemporain, Geneva

"From the Collection: Photography, Sculpture, Painting," Whitney Museum of American Art, New York

"Don't Look Now," Thread Waxing Space, New York

1993–96

"Empty Dress: Clothing as Surrogate in Recent Art," organized by Independent Curators International, New York [traveling: Neuberger Museum of Art, Purchase, NY; Virginia Beach Center for the Arts, VA; University Art Gallery, University of North Texas, Denton; Grenfell Campus Art Gallery, Sir Wilfred Grenfell College, University of Newfoundland, Canada; Mackenzie Art Gallery, Regina, Canada; Gallery Stratford, Canada; California Center for the Arts, Escondido; Selby Gallery, Ringling School of the Arts, Sarasota, FL; Rubelle and Norman Schafler Gallery, Pratt Institute, Brooklyn, NY]

1993–94

"Photoplay: Works from the Chase Manhattan Collection," Center for the Fine Arts, Miami [traveling: Museo Amparo, Puebla, Mexico; Centro Cultural Consolidado, Nacional de Bellas Artes, Buenos Aires; Museo Nacional de Bellas Artes, Santiago, Chile]

"Commodity Image," International Center of Photography, New York [traveling: Institute of Contemporary Art, Boston; Laguna Art Museum, Laguna Beach, CA]

1993

"Image Makers," Nassau County Museum of Art, Roslyn Harbor, NY

"The Return of the Cadavre Exquis," the Drawing Center, New York

"Here's Looking At Me / A Mes Beaux Yeux: Autoportraits Contemporains," L'Espace Lyonnais d'Art Contemporain, Lyon, France

1992–93

"The Boundary Rider: 9th Biennale of Sydney," Art Gallery of New South Wales, Australia

1992

"The Disasters of War," Centro Cultural Arte Contemporáneo, Polanco, Mexico

"The Photographic Order from Pop to Now," International Center of Photography, New York

"Quotations: The Second History of Art," Aldrich Contemporary Art Museum, Ridgefield, CT

"Knowledge: Aspects of Conceptual Art," University Art Museum, Santa Barbara, CA [traveling:

Santa Monica Museum of Art, CA; North
Carolina Museum of Art, Raleigh]

1991
"American Art of the 80's," Palazzo delle Albere,
Museo d'Arte Moderna e Contemporanea di
Trento e Rovereto, Trento, Italy
"Beyond the Frame: American Art 1960–1990,"
Setagaya Art Museum, Tokyo [traveling:
National Museum of Art, Osaka, Japan;
Fukuoka Art Museum, Japan]
"Motion and Document, Sequence and Time:
Eadweard Muybridge and Contemporary
American Photography," National Museum
of American Art, Smithsonian Institution,
Washington, DC
"Recent Work/Recent Acquisitions," Museum of
Contemporary Art, Los Angeles
"The Interrupted Life," New Museum, New York
"Cruciformed: Images of the Cross since 1980,"
Cleveland Center for Contemporary Art, OH
"Selections from the Permanent Collection:
1975–1991," Museum of Contemporary Art,
Los Angeles

1990
"Figuring the Body," Museum of Fine Arts, Boston
"Fragments, Parts, Wholes; The Body & Culture,"
White Columns, New York
"The Indomitable Spirit," International Center of
Photography, New York [traveling: Los Angeles
Municipal Art Gallery]
"Taking the Picture: Photography and
Appropriation," Leo Castelli Gallery, New York
"Reorienting: Looking East," Nicola Jacobs
Gallery, London; Third Eye Center, Glasgow

1989–90
"Shifting Focus: An International Exhibition
of Contemporary Women's Photography,"
Cambridge Darkroom, England [traveling:
City Museum and Art Gallery, Stoke-on-Trent,
England; Newport Museum and Art Gallery,
England; Harris Museum and Art Gallery,
Preston, England]

1989
"Image World: Art and Media Culture," Whitney
Museum of American Art, New York
"Moskau - Wien - New York: Kunst zur Zeit,"
Messepalast, Vienna
"Selections from the Collection of Marc and Olivia
Straus," Aldrich Museum of Contemporary Art,
Ridgefield, CT
"The Play of the Unsayable-Wittgenstein and the
Art of the XXth Century," Vienna Secession
"Avant 1989," FRAC Rhône-Alpes, Lyon, France
"Abstraction in Contemporary Photography,"
Emerson Gallery, Hamilton College, Clinton,
NY [traveling: Anderson Gallery, Virginia
Commonwealth University, Richmond]
"Vis-A-Vis: Aspects of Contemporary Portrait
Photography," Galerie Grita Insam, Vienna
[traveling: Museum voor Hedendaagse
Kunst Het Kruithuis, 's-Hertogenbosch, the
Netherlands]

"Culture Medium: A Notion of Truth," International
Center of Photography, New York
"A Forest of Signs: Art in the Crisis of
Representation," Museum of Contemporary Art,
Los Angeles
"The Photography of Invention: American Pictures
of the 1980s," National Museum of American
Art, Smithsonian Institution, Washington,
DC [traveling: Museum of Contemporary Art,
Chicago; Walker Art Center, Minneapolis, MN]
"Contemporary Perspective I: Abstraction in
Question," John and Mable Ringling Museum of
Art, Sarasota, FL
"What Does She Want?: Current Feminist Art
from the First Bank Collection," Carleton Art
Gallery, Carleton College, Northfield, MN
[traveling: Women's Art Registry of Minnesota,
Minneapolis]

1988
"Hybrid Neutral: Modes of Abstraction and
the Social," University Art Gallery, University
of North Texas, Denton [traveling: J.B.
Speed Art Museum, Louisville, KY; Alberta
College Gallery of Art, Canada; Cincinnati
Contemporary Art Center, OH; Richard F.
Brush Art Gallery, Santa Fe Community
College Art Gallery, NM]
"The Discursive Field of Recent Photography,"
ArtCulture Resource Center, Toronto
"Art at the End of the Social," Rooseum Center for
Contemporary Art, Malmö, Sweden
"Photography on the Edge," Haggerty Museum of
Art, Marquette University, Milwaukee, WI
"Sexual Difference: Both Sides of the Camera,"
Wallach Art Gallery, Columbia University,
New York
"Just Like a Woman," Greenville County Museum
of Art, SC
"The Return of the Hero," Burden Gallery /
Aperture Foundation, New York
"Female (Re)production," White Columns, New York

1987–88
"Art and Its Double: A New York Perspective,"
Sala de Exposiciones de la Fundación Caja de
Pensiones, Madrid [traveling: Fundació Caixa
de Pensions, Barcelona]

1987
"This is not a Photograph: Twenty Years of Large
Scale Photography; 1966–1986," John and
Mable Ringling Museum of Art, Sarasota, FL
[traveling: Akron Museum of Art, OH; Chrysler
Museum of Art, Norfolk, VA]
"Contemporary Diptychs: The New Shape of
Content," Whitney Museum of American Art
at Champion Plaza, Stamford, CT; Whitney
Museum of American Art at Equitable Center,
New York
"Recent Tendencies in Black and White," Sidney
Janis Gallery, New York
"Contemporary Photographic Portraiture,"
Musée St. Pierre, L'Espace Lyonnais d'Art
Contemporain, Lyon, France

1986
"The Big Picture," Queens Museum of Art, New York
"As Found, part III of Dissent: The Issue of Modern
Art in Boston," Institute of Contemporary Art,
Boston
"Aperto," Venice Biennale

1985–86
"Infotainment," Rhona Hoffman Gallery, Chicago
[traveling: Texas Gallery, Houston; Aspen Art
Museum, CO; Vanguard Gallery, Philadelphia,
PA]

1985
"Playing It Again, Strategies of Appropriation,"
Institute for Contemporary Arts, Santa Fe, NM
"Figure it Out," Laguna Gloria Art Museum, Austin,
TX
"Seduction Working Photographs," White
Columns, New York
"Whitney Biennial 1985," Whitney Museum of
American Art, New York
"The Art of Memory, The Loss of History," New
Museum, New York
"Public Art," Nexus Contemporary Art Center,
Atlanta, GA [traveling: C.W. Woods Gallery,
Hattiesburg, MS; Carolina Program Union,
Columbia, SC; Austin Peay State University,
Clarksville, TN; Valencia Community College,
Orlando, FL; North Carolina Museum of Art,
Raleigh; University of the South, Sewanee, TN]
"Cult and Decorum," Tibor de Nagy Gallery, New
York

1984–85
"Between Here and Nowhere," Riverside Studios,
London [traveling: Kettle's Yard, Cambridge,
England; Midland Group Gallery, Nottingham,
England]

1984
"Ten Years of Contemporary Art," Museum of
Modern Art / Art Advisory Service, New York
"The New Capital," White Columns, New York

1983
"Terminal New York," Brooklyn Army Terminal, New
York
"In Plato's Cave," Marlborough Gallery, New York

1982
"Art and the Media: A Fatal Attraction,"
Renaissance Society, University of Chicago

1981
"New Wave," P.S.1 Contemporary Art Center,
Long Island City, NY

1980
"Times Square Show," New York

1979
"The Altered Photograph," P.S.1 Contemporary
Art Center, Long Island City, NY

Contributors

Johanna Burton is *Keith Haring Director and Curator of Education and Public Engagement* at the New Museum.

David Clarkson is an artist and a writer based in Toronto. Since 2010, he has taught in the Interdisciplinary Graduate Studies Program of Ontario College of Art and Design University (OCAD), Toronto.

Hal Foster is *Townsend Martin, Class of 1917, Professor of Art and Archaeology* at Princeton University and Coeditor of the journal *October* as well as October Books.

Barbara Kruger is an artist based in New York. She is known for collage and installation-based works that challenge cultural constructions of power, identity, and sexuality.

Kate Linker is a political and social activist and President of the Board of Directors of Greater NYC for Change. She was formerly a contemporary art writer with a focus on issues of sexuality and representation.

Margot Norton is Associate Curator at the New Museum.

Lisa Phillips is *Toby Devan Lewis Director* at the New Museum.

Cindy Sherman is an artist based in New York. Her photographic portraits explore the artifice of identity and representation.

Laurie Simmons is an artist based in New York. Her multidisciplinary work in film and photography critiques the representation of gender roles in the media.

Sara VanDerBeek is an artist based in New York. She is known for evocative photographs of sculptural and still-life tableaux that she arranges in her studio.

This book has been published on the occasion of the
New Museum exhibition

SARAH CHARLESWORTH: DOUBLEWORLD
New Museum, New York
June 24–September 20, 2015

"Sarah Charlesworth: Doubleworld" is made possible by
the Robert Mapplethorpe Foundation.

Lead exhibition support provided by the
Friends of Sarah Charlesworth at the New Museum:
Ara Arslanian
Melva Bucksbaum and Raymond Learsy
Joseph Kosuth
Margo Leavin
Toby Devan Lewis
Maccarone Gallery, New York
Peter Marino
Tony Shafrazi
S.L. Simpson
Neda Young

This catalogue is made possible by the J. McSweeney and
G. Mills Publications Fund at the New Museum.

"Stills" is presented in association with the
Art Institute of Chicago.

Curators: Massimiliano Gioni, Artistic Director, and
Margot Norton, Associate Curator
New Museum Editor: Frances Malcolm
New Museum Assistant Editor: Olivia Casa
Graphic Design: Joseph Logan and Rachel Hudson
Printed by The Avery Group at Shapco Printing, Minneapolis

First published in the United States in 2015 by
New Museum
235 Bowery, New York, NY 10002
www.newmuseum.org

ISBN 978-0-915557-08-0

Cover: *Black Mask*, from the "Objects of Desire" series,
1983. Cibachrome print with lacquered wood frame,
42 x 32 in (106.7 x 81.3 cm)

NEW
235 BOWERY
NEW YORK NY
10002 USA
MUSEUM

JUL – 8 2015